PANORAMA
NOVA SCOTIA

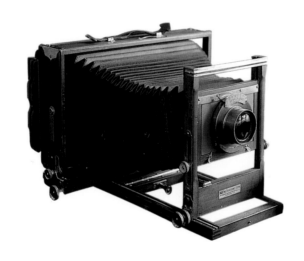

Nimbus Publishing Limited
P.O. Box 9301, Station A
Halifax, N.S. Canada
B3K 5N5
Tel. (902) 455-4286

Design: Sherman Hines
Text edited by Jennifer Lambert
Special thanks to:
Bruce Law
Jim Laceby of Blomidon Inn
Doug Fawthrop of White Point Beach Lodge

© All photographs by Sherman Hines 1998
Film used: Fuji film 100 ISO

Prints are available from the Sherman Hines Museum of Photography
Liverpool, N.S. Canada,
B0T 1K0
Tel. (902) 354-2667

Stock photo usage available from:
Masterfile
175 Bloor St. E., South Tower, 2nd Floor
Toronto, Ont, Canada
M4W 3R8
Tel: (416) 929-3000 Fax: (416) 929-2104

Half title page: the wide-field camera belonging to E. Graham of Wolfville, N.S.
The photo on page 10 was taken with this camera.

Full title page: Blomidon Inn, Wolfville, N.S. 1-800-564-2291

Page 6 top: Ste. Croix, Reid Studio, Windsor, N.S.
 bottom: Bridgewater, Dodge Studio, Sydney, N.S.

Page 7 top: Tiverton, Hardy Studio, Kentville, N.S.
 bottom: Sydney Steel Mill, Dodge Studio, Sydney, N.S.

Page 11 top: Waterfowl, Hants County
 bottom: Surf, Ingonish, N.S.

Page 12-13: The outgoing tide of the Ste. Croix River near Brooklyn, Hants Co.

Canadian Cataloguing in Publication Data
Hines, Sherman, 1941—
ISBN 1•55109•247•6
1. Nova Scotia - Pictorial works. I. Title.

Printed and bound by Everbest Printing Company Ltd., Hong Kong

PANORAMA
NOVA SCOTIA

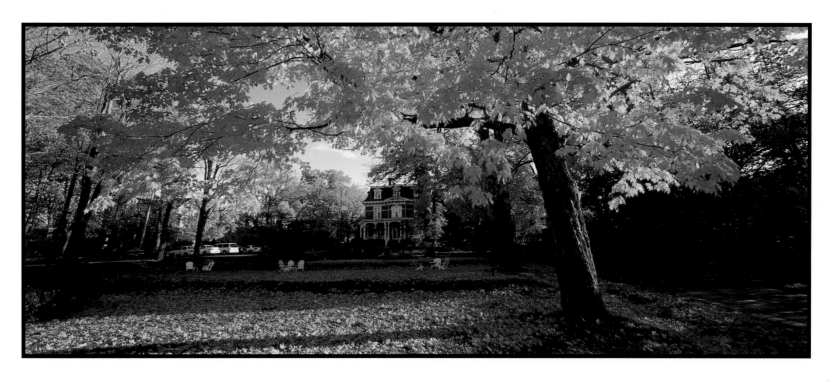

Photography by Sherman Hines

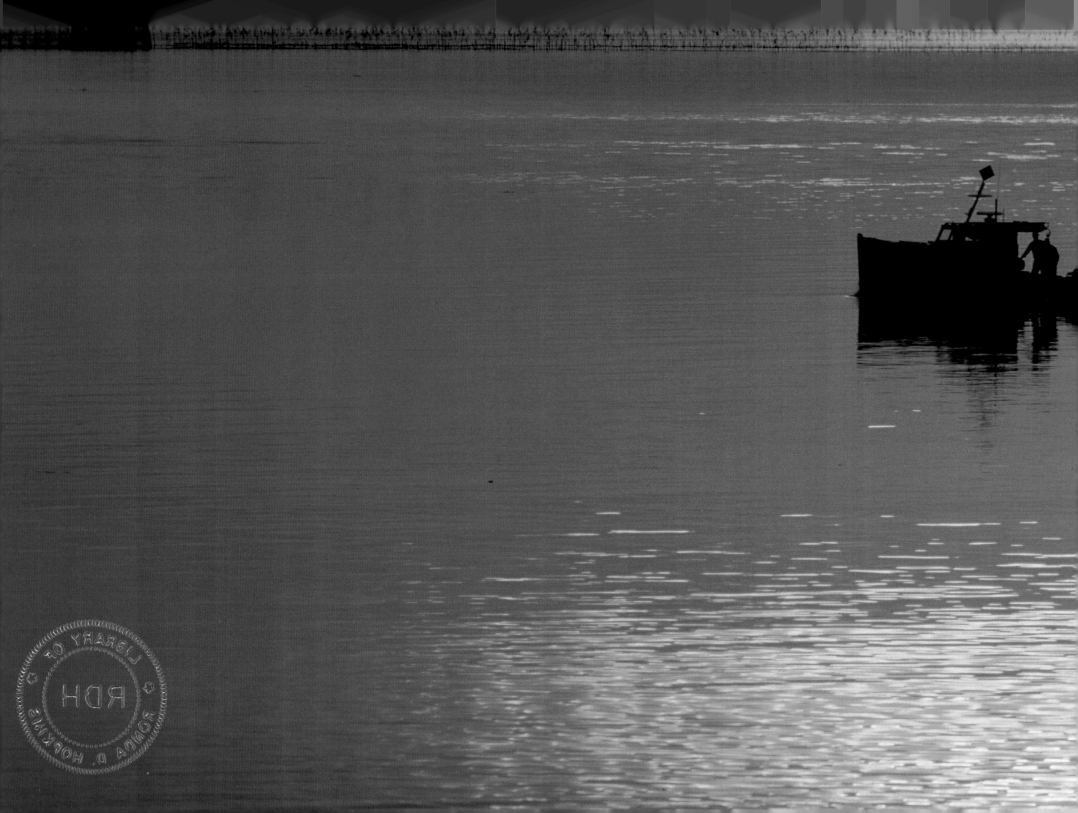

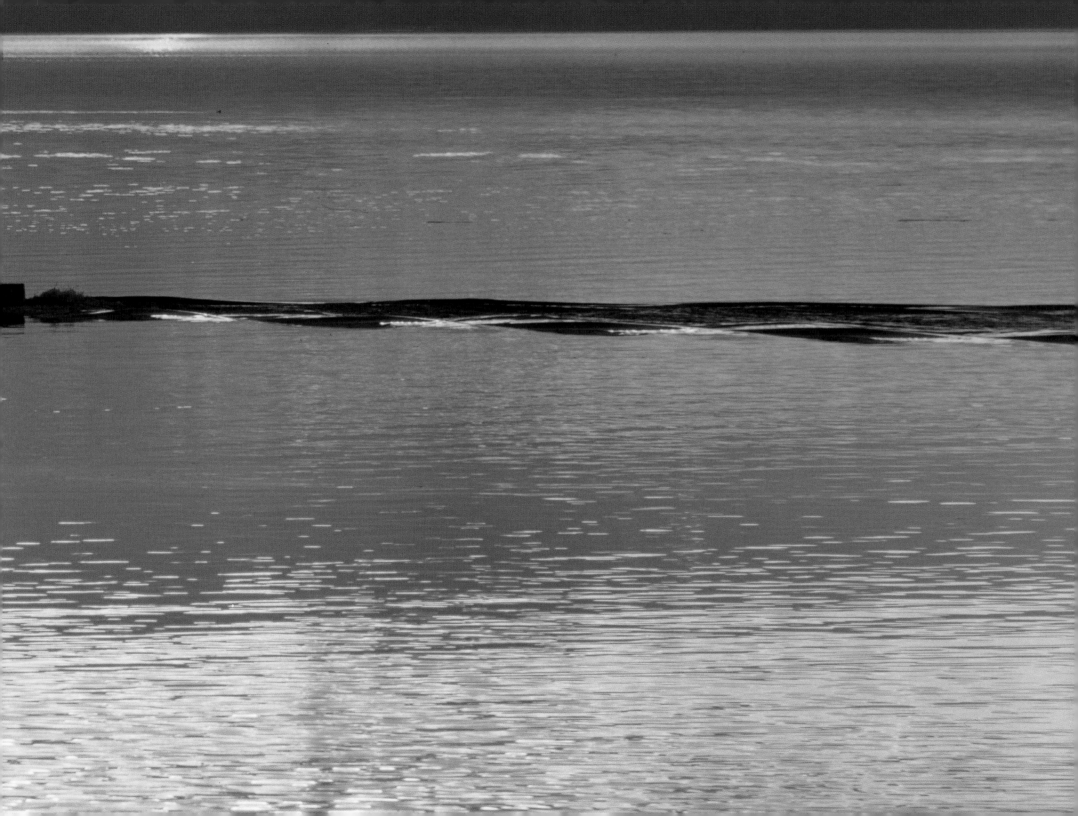

~ INTRODUCTION ~

Nova Scotia is truly a mecca for the landscape photographer. The riveting drama of the Cabot Trail, the picturesque fishing communities which dot the province's coastline, the rich architectural heritage of her cities and towns—it seems that one has only to point a camera and click the shutter to capture a memorable panorama of this dynamic and bewitching province.

The diversity of Nova Scotia's physical geography is welded together by the sea, which is never more than 35 miles from any part of the province. Almost an island, Nova Scotia is linked to 'mainland' Canada by the narrow strip of land known as the Isthmus of Chignecto. On one side of the Isthmus are the sandy beaches that characterize the coastline of the Northumberland Strait, on the other the spectacular sea cliffs and intriguing salt marshes created by the awesome tides of the Bay of Fundy. The eastern length of the province confronts the Atlantic Ocean, whose relentless force has created sweeping beaches, sculptured cliffs, and coastal dunes.

However, if Nova Scotia is shaped by the sea, the province also boasts magnificent inland spaces, including many lakes, rivers and freshwater marshes, a haven for migratory waterfowl. The mature hardwood forests deliver a dazzling array of colours in the autumn, while springtime welcomes a host of wildflowers in the province's abundant meadows and woodlands.

Nova Scotia's human geography is as myriad in its making as is her landscape. Evidence of native settlement dates back to 9000 BC, and there were certainly Mi'kmaq communities scattered throughout Nova Scotia, primarily on Cape Breton Island, when

Europeans arrived in the sixteenth century to cash in on the lucrative fishery and fur trades. The French established the first European permanent settlement at Port Royal in 1605, and the ensuing struggle between French and English resulted in the tragic expulsion of the Acadians, those French farmers who had reclaimed the marshlands and settled in the fertile Annapolis Valley. Thus began a period of mass immigration, as the British began to implement their policy of colonizing and fortifying Nova Scotia as a buffer zone against possible French designs on New England. English settlers established the town of Halifax in 1749, while German, Swiss and French Protestants arrived soon after to shore up the ranks. In 1758 the New England Planters, known variously as 'neutral Yankees' and 'pre-Loyalists,' were invited by the Crown to settle those lands taken from the Acadians, and a generation later they were followed by 20,000 Loyalists, who flooded into Nova Scotia in the wake of the American Revolution. Though usually portrayed as uniformly white, British, and Anglican, the Loyalists numbered amongst them Catholic Scottish Highlanders, Irish, Germans, and 3,500 Black Loyalists.

The following two centuries saw a steady accumulation of Irish, Scottish and other European immigrants, as well as significant numbers of Lebanese. And so Nova Scotia's human landscape developed, building upon and blending into the province's natural landscape, creating innumerable and unforgettable panoramas for the heart, mind, and eye.

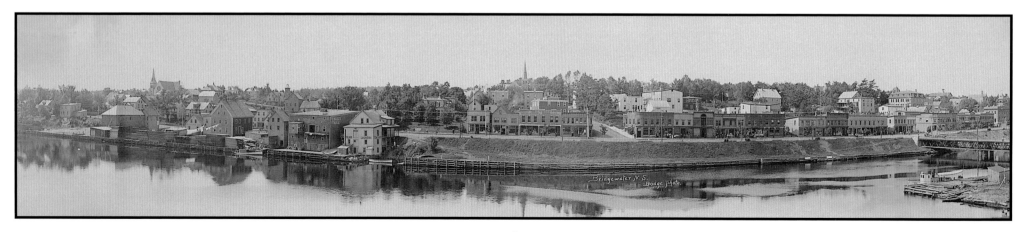

A panorama is essentially an unbroken or wide scenic view. The current photographic trend towards this type of image has emerged over 150 years after Frederic Martens' pioneering efforts with panoramic photography. Designed in 1845, his first camera was equipped with a moving lens, while the film was bracketed in a curved position in order to retain focus. Alternative models enabled the camera itself to move as the opening lens travelled slowly across the film. This provided great scope for 'trick' photography as an enthusiastic subject could begin by being photographed at one end of a group portrait before dashing to the other end to be included once again as the lens advanced to the opposite side! In 1896 the Al Vista was created, a panoramic camera able to take both standard proportion pictures and panoramic views, similar to modern three-format cameras.

Having begun by considering the evolution of the panoramic camera, I hasten to explain that wide-field-of-view photography should not be confused with panoramic photography. The photographs in this book are the result of using a wide-angle lens, and the images were cropped horizontally to produce photographs with a wide field of coverage. I used two different cameras: a specially designed Fujica 6 x 17 which takes 120 mm and 220 mm film, and a Pentax 6 x 7 format camera with wide-angle 45 mm and 55 mm lenses, whose images get proportionally cropped to a 6 x 17 wide-field photograph.

As a professional photographer, I am constantly challenged to choose the correct format and lens when producing an image. My choice depends on several factors. In commercial work, the layout and design—in conjunction with the client's requirements—generally dictate the appropriate selection of both lens and format.

However, with pictorial or scenic photography the image is one which informs and pleases me. In this instance, composition is by far the strongest factor in selecting a format. The subject itself visually dictates to me the best focal length of lens to use. The scenes in this book have been photographed in several different formats and focal lengths in order to demonstrate the degree to which the camera can be used as an instrument of expression.

In terms of the images themselves, I am often asked why I chose to take a specific photograph, what directed me towards that particular subject. Unlike the intrepid mountaineer, I do not approach an image simply 'because it is there.' My photographs result from the fact that I am constantly directed by light, colour, movement, composition, shape, form, impact, subject and, most importantly, by nature itself.

Many years ago I found myself consistently frustrated by the photographs I was producing. My images seemed to me stilted and unpleasing, with very little heart. I realized that I was forcing my own sense of image on the environment instead of allowing the environment to inform my images. I discovered that one can only truly see an image by listening to and developing a sense of the natural elements in one's surroundings. Only then can an image truly come into vision, and when it does it tells the photographer exactly what to do.

When choosing a wide-field format, do make sure it's the right choice. Don't reduce this unique form of photography to mere gimmickry. Instead, approach it as a valuable tool with which to express yourself. And above all else, take joy in your work.

Sherman Hines

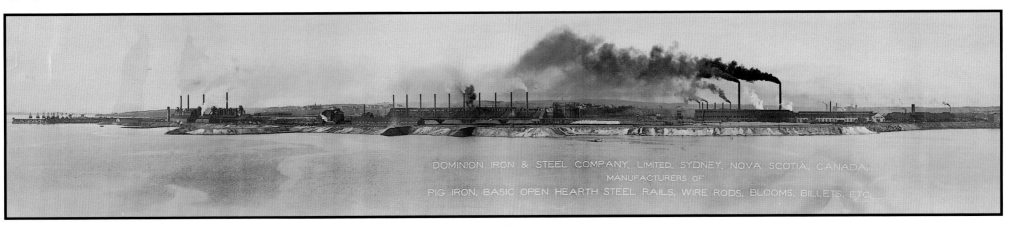

DOMINION IRON & STEEL COMPANY, LIMITED, SYDNEY, NOVA SCOTIA, CANADA.
MANUFACTURERS OF
PIG IRON, BASIC OPEN HEARTH STEEL RAILS, WIRE RODS, BLOOMS, BILLETS, ETC.

This book is dedicated to the late Eric Hubner of Fuji Film Canada, who upon gifting me the first
Fujica 6 cm x 17 cm imported into Canada, planted the seed of my love of wide-field photography.
and
To Gene Picard, my friend of many years, a great collector and a master photographer.

—Sherman Hines

Good photography captures a moment in time; great photography reveals the infinite property of time itself. Charged with fleeting patterns of light and colour, Sherman Hines' landscape images reach out through the flat surface of their pages and expand into the boundless world of our imagination. Stained on Fuji film, dusk is absorbed by light and shadows; sunrise inches forward in frames. The natural world frequently overwhelms the untrained eye, but Hines' unerring sense of composition, light, and colour guides the viewer into invisible landscapes, offering us a glimpse of nature's intricacies.

Panorama Nova Scotia is a body of work that makes plain the photographer's own pluralistic relationship to nature. His images combine an Eastern sensibility—spiritual awe—of the natural world with an insatiable Western inquisitiveness, the desire to probe crevices, to break things apart, to examine them and then to reassemble the pieces. The Western tendency to see nature as an object to conquer, or contain—as the camera lens frames its subject—is confirmed by Hines' compositions, which resist their edges; his skies push up; his horizons lengthen. Like a caged cloud, these images are both captured and yet free to expand and broaden in the mind's eye.

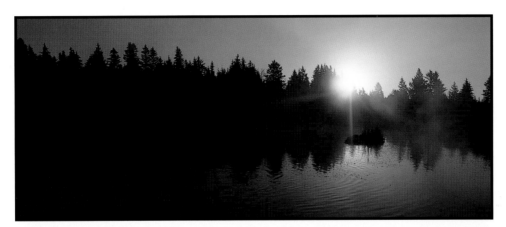

While Hines' aesthetic sensibility is formalistic in his resolute attention to composition, his work communicates a distinct humanistic and even metaphysical quality. The majority of the images in the following pages seek to convey nature's sheer magnificence, while others allude to man's relationship to and intervention upon the natural world. The first to express his gratitude for nature's refusal to repeat herself, Hines is able to capture again and again the perfections and inconsistencies of his natural environment. Whether the subject be a delicate flower or a majestic panorama, his compositions are at once familiar and fresh. His mastery of the camera and assiduous observance of visual order imbue his work with a recognizable style, one that never obstructs the essence of his subject. However, simple representation is not his primary concern, and Hines does not permit the camera to govern his art. His photographs—those ineluctable points of entry into the invisible geometry of distance—are the result of a lifetime spent listening to nature, an enhanced observation of the natural world around him.

Blair David

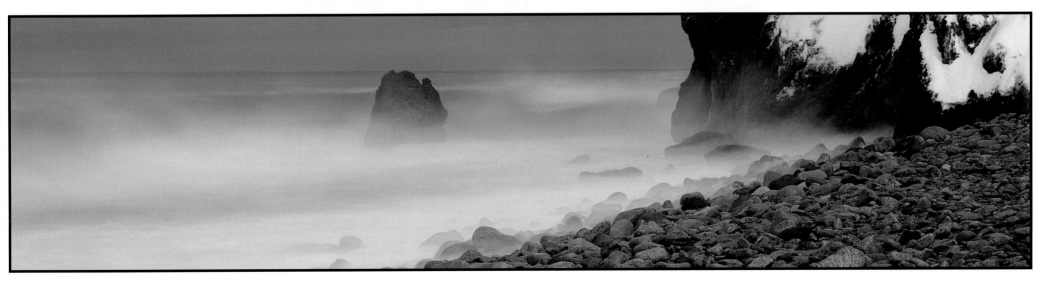

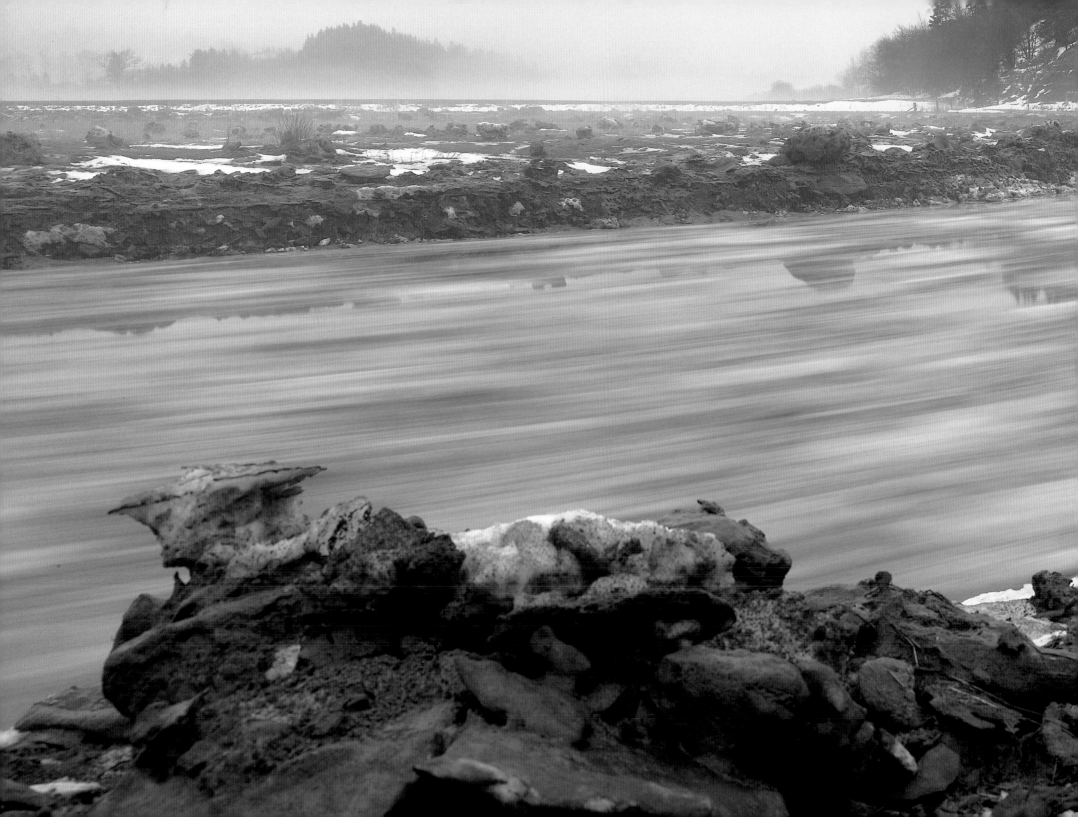

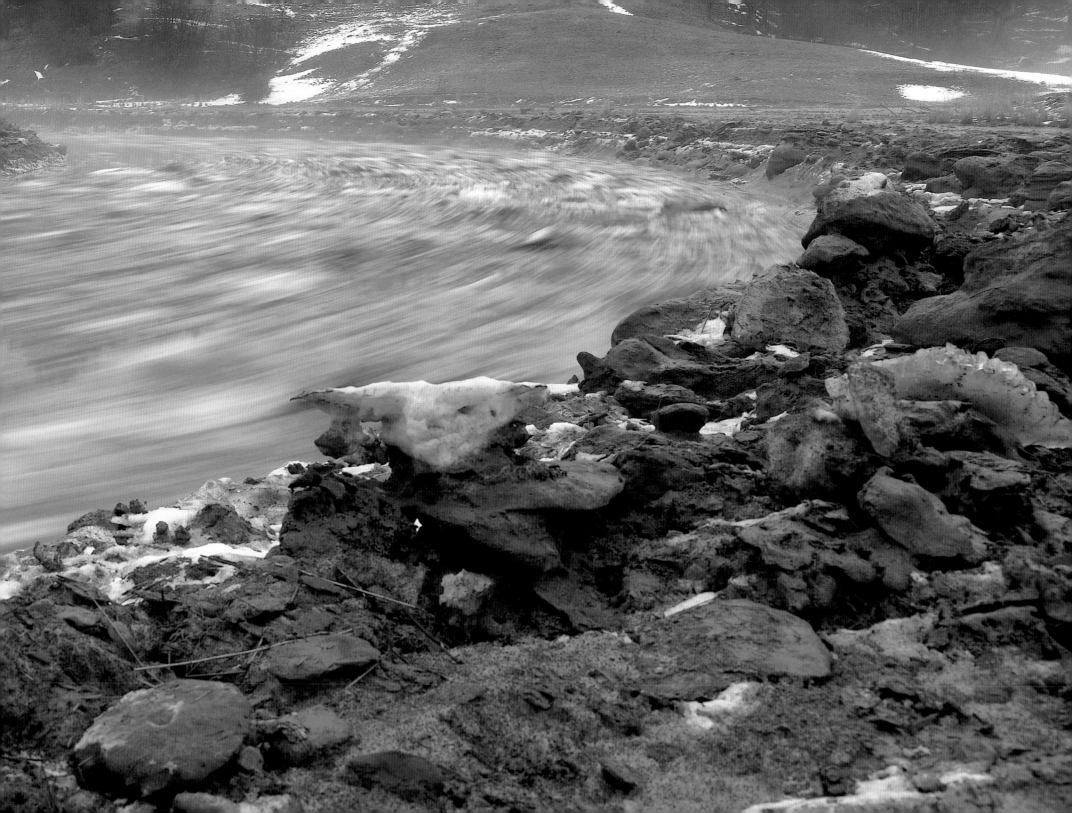

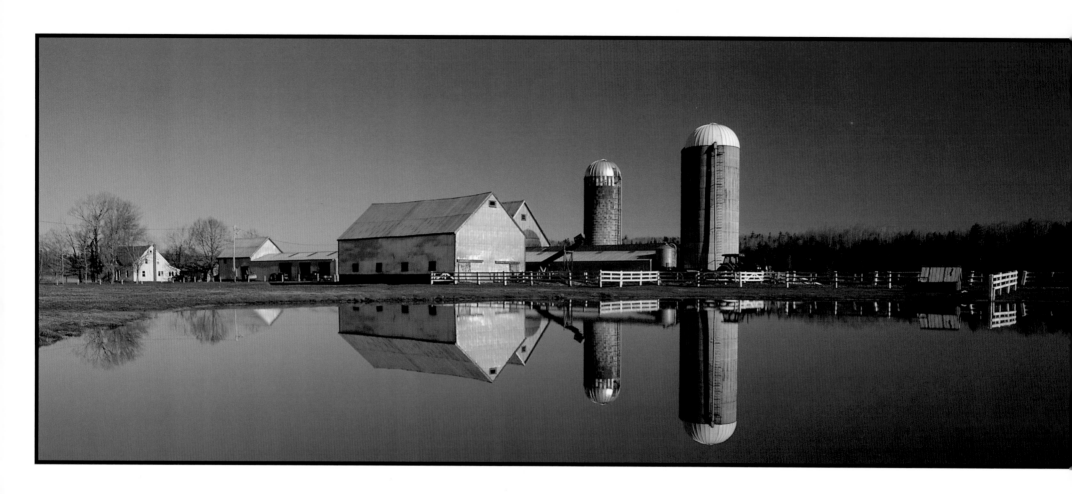

A very photogenic farm along the Rawdon Road near Brooklyn, Hants Co.

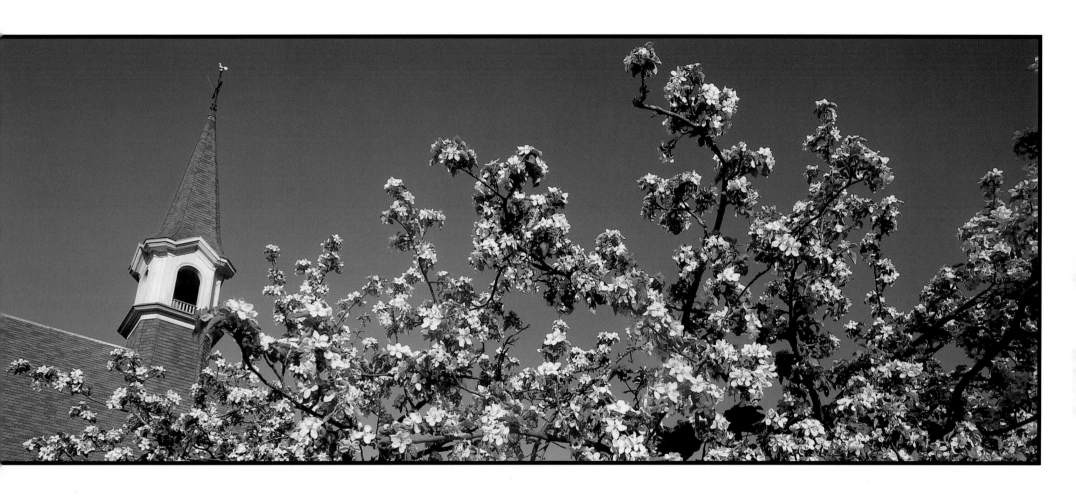

Grand Pré apple orchard in May.

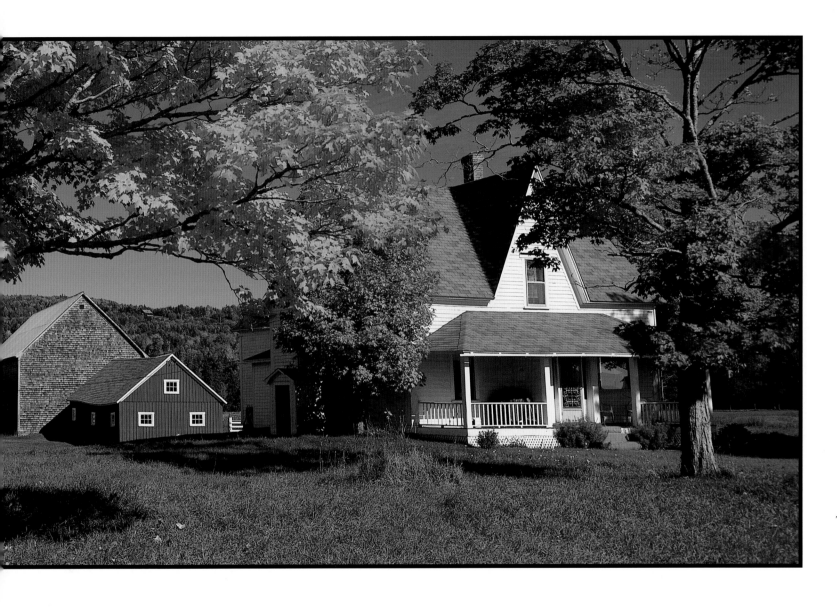

The Ross farm in the beautiful Margaree
Valley of Cape Breton.

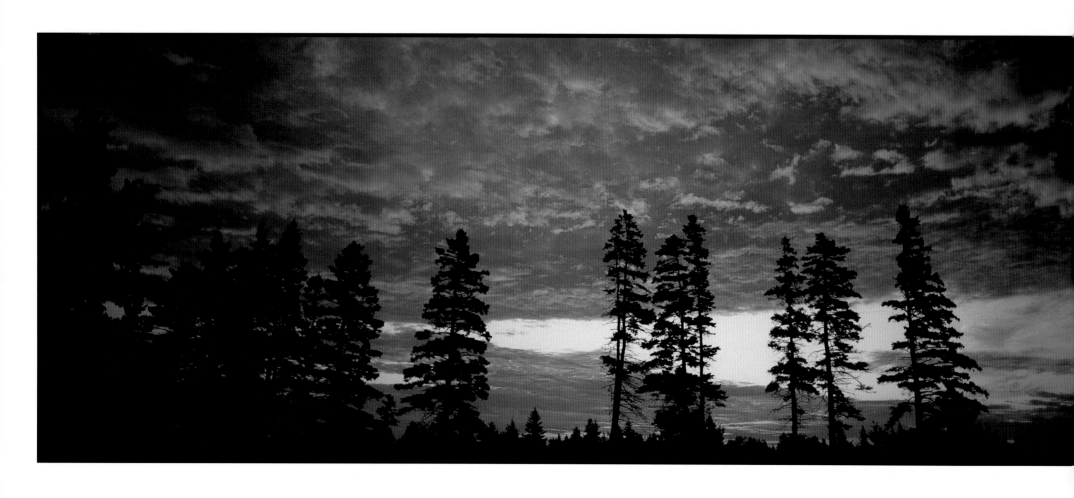

Sunsets like these are always a memory of the end of a beautiful day.

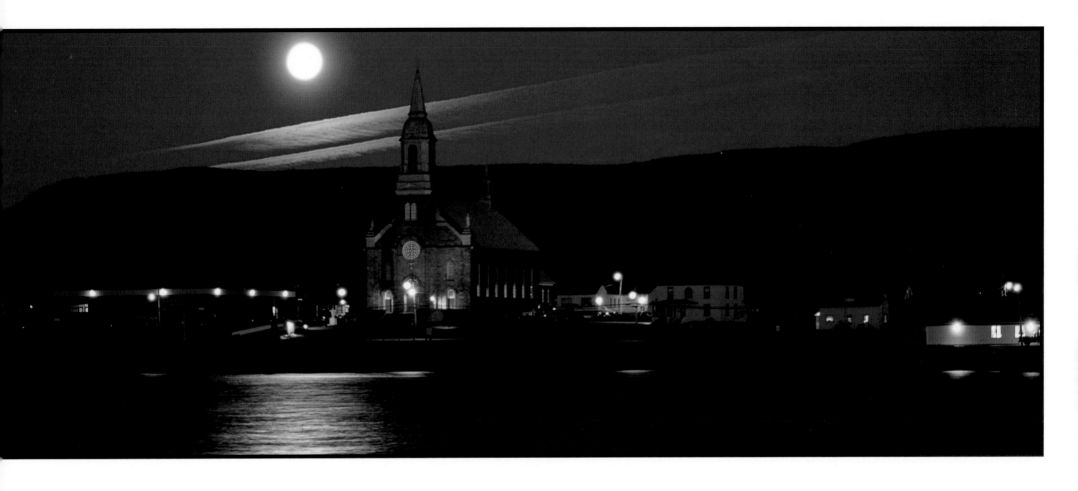

The church at Chéticamp on the west coast of Cape Breton in the light of the moonrise.

Overleaf: Grand Pré church and gardens are a stark contrast from the summer season.
The British expulsion of the Acadians took place in this area in 1755.

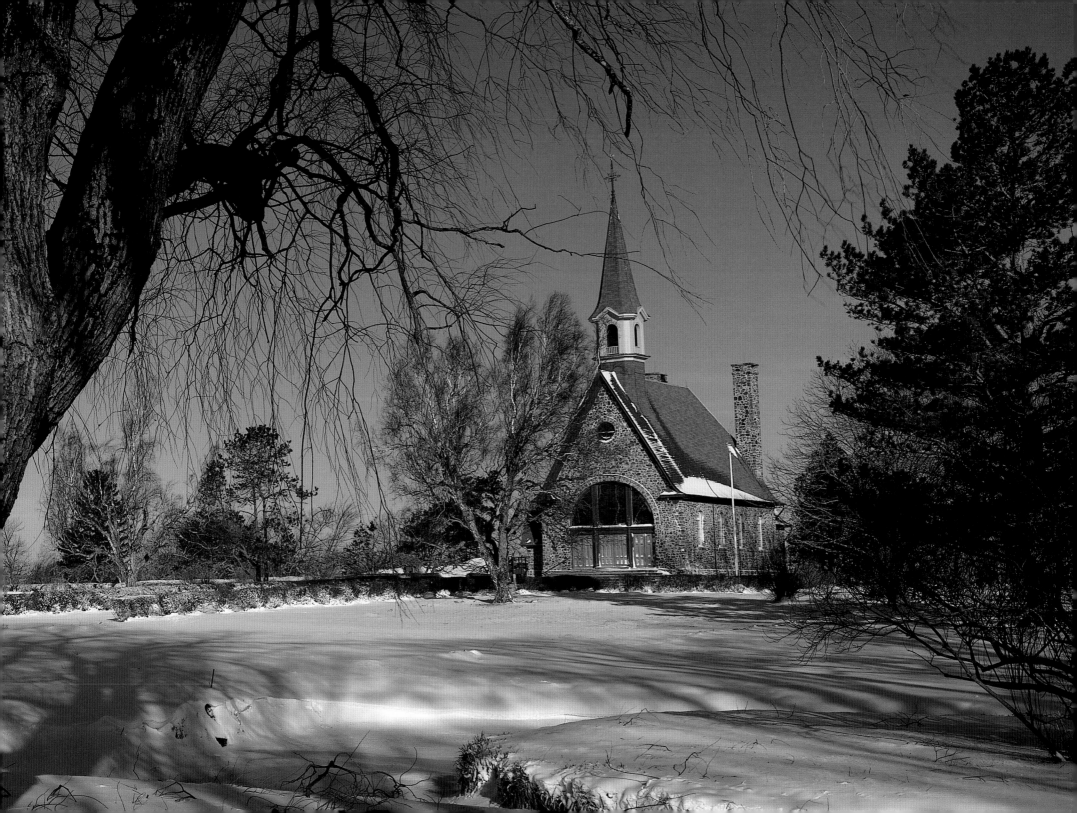

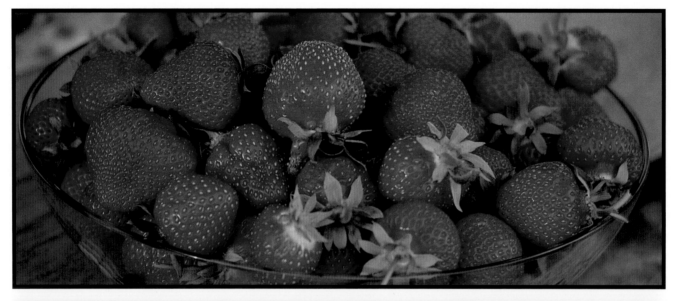

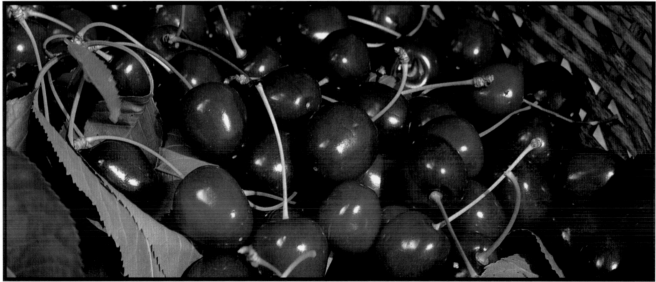

A bountiful harvest of strawberries, plums, and cherries fill the pots, jars, and bowls of consumers.

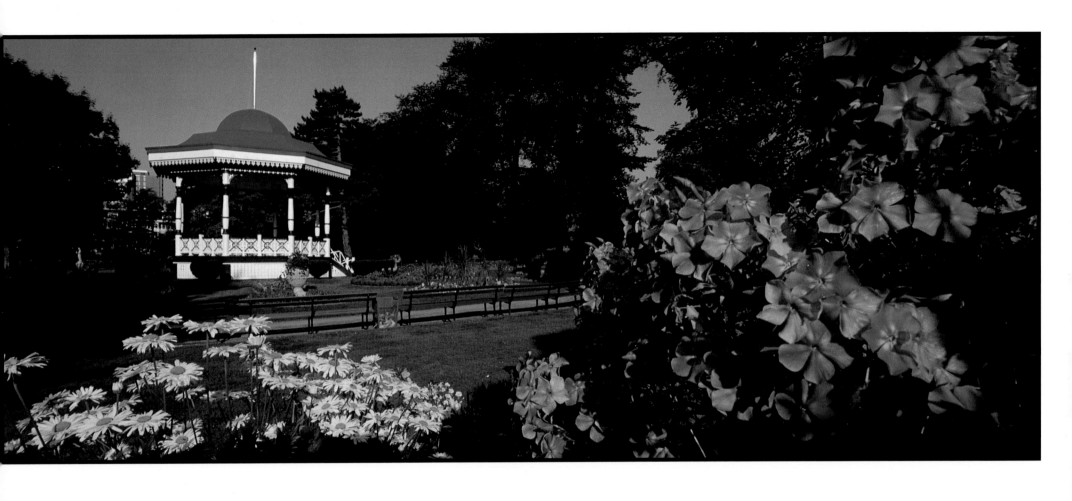

The band shell in the beautiful Victorian gardens in the centre of the city of Halifax.

Overleaf: Cape Forchu Light, Yarmouth.

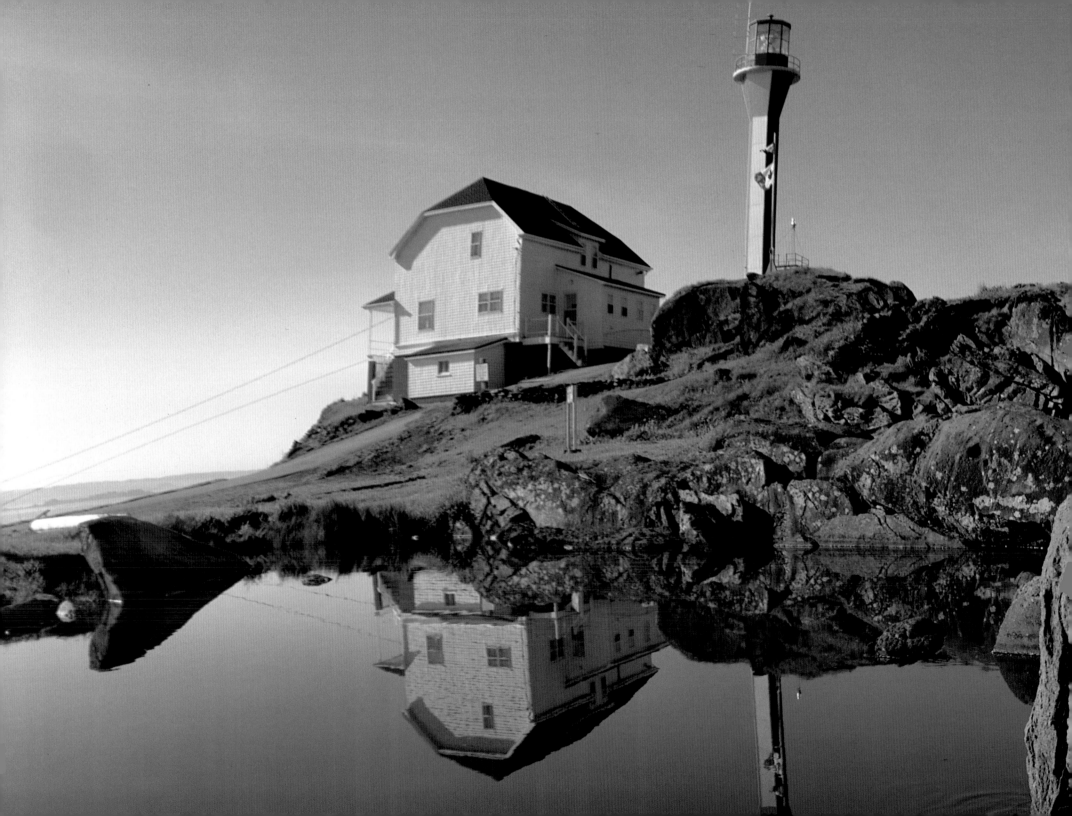

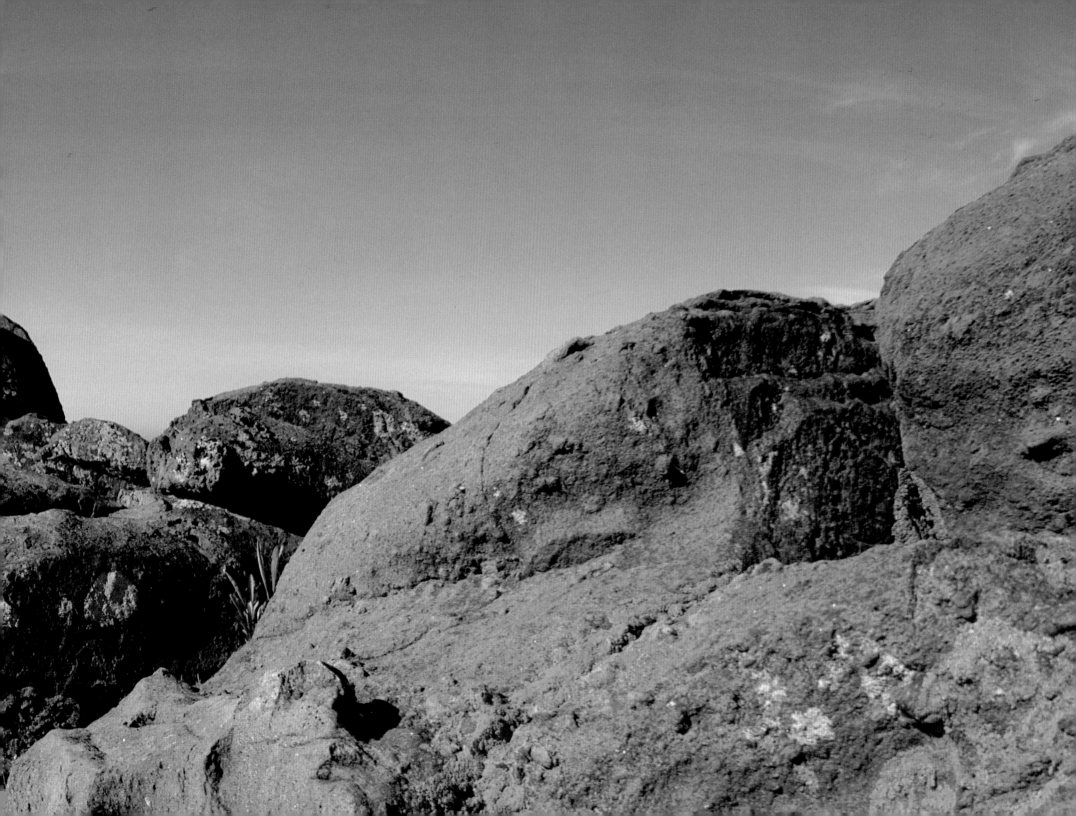

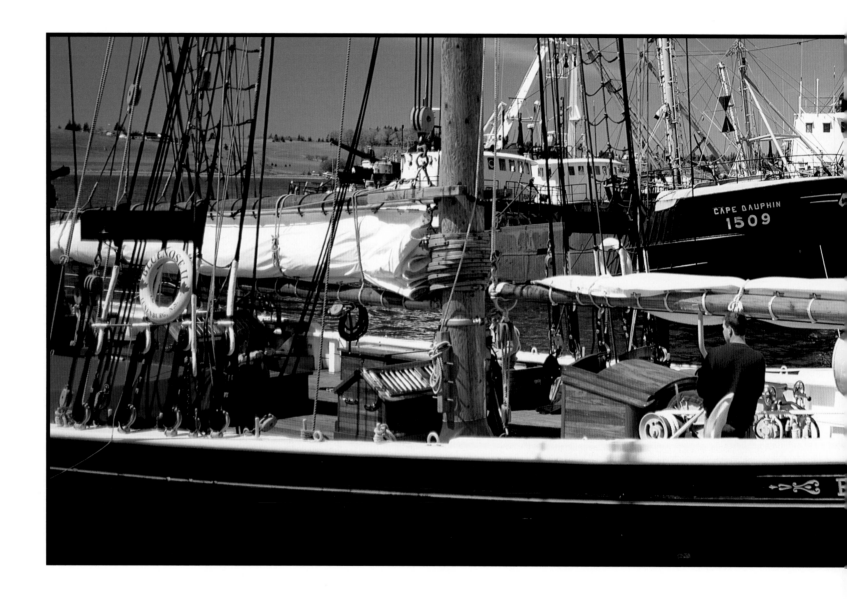

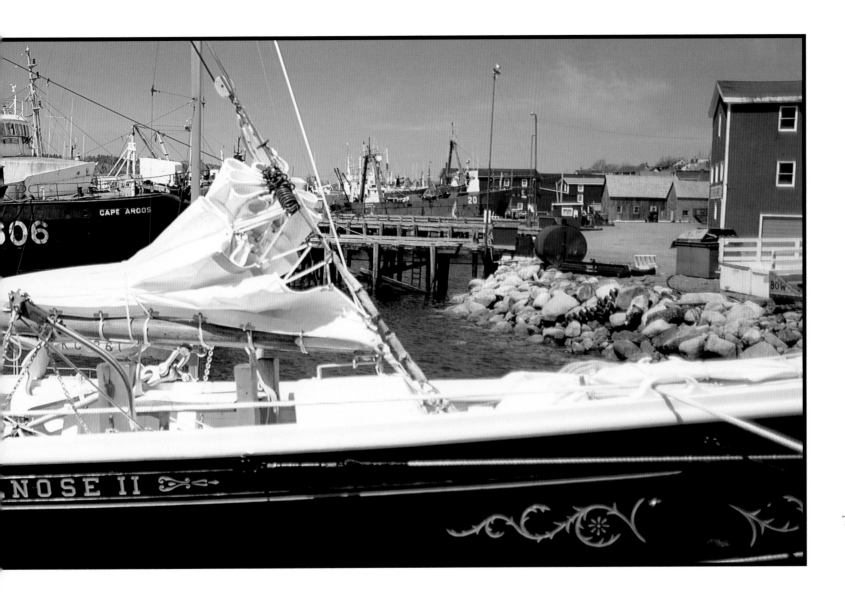

The Bluenose II at home in Lunenburg. Famous as the sailing ship on the Canadian dime and as a champion of many international races.

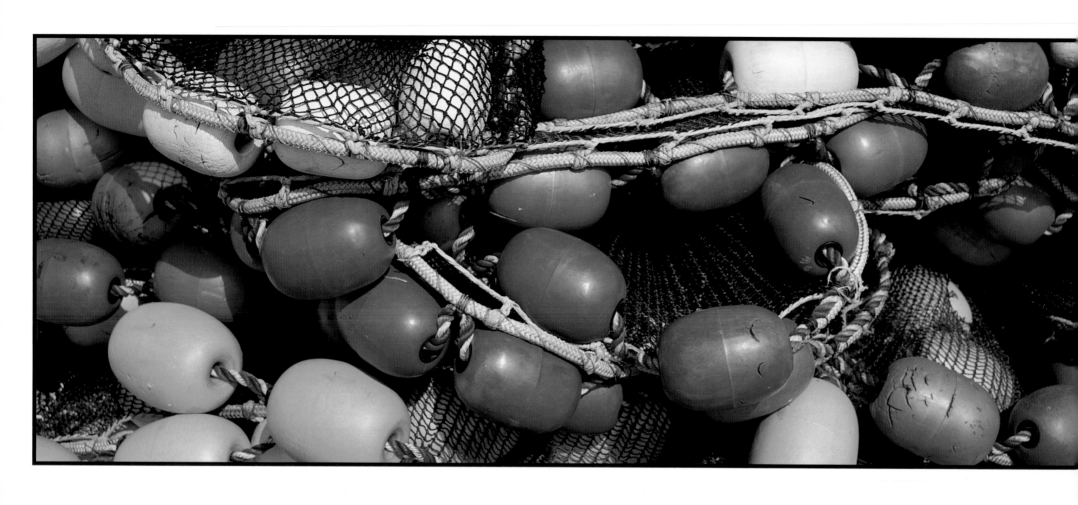

The floats of a surface net are colourful so they are easily seen in the fog and rough waters.

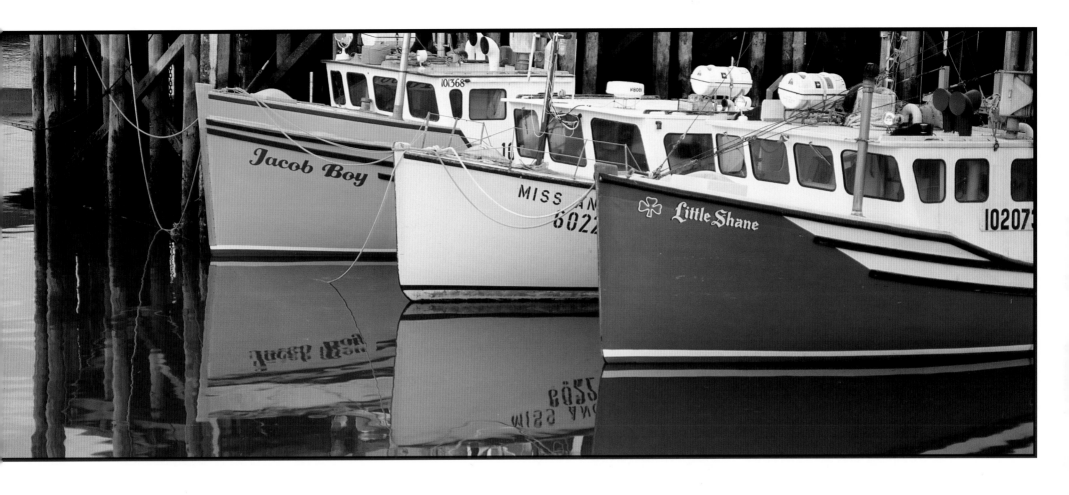

Hundreds of small coves and harbours around Nova Scotia are home to inshore fishing boats such as these—only the names are changed.

Overleaf: Peggy's Cove is always a delightful experience, especially on a foggy day in July.

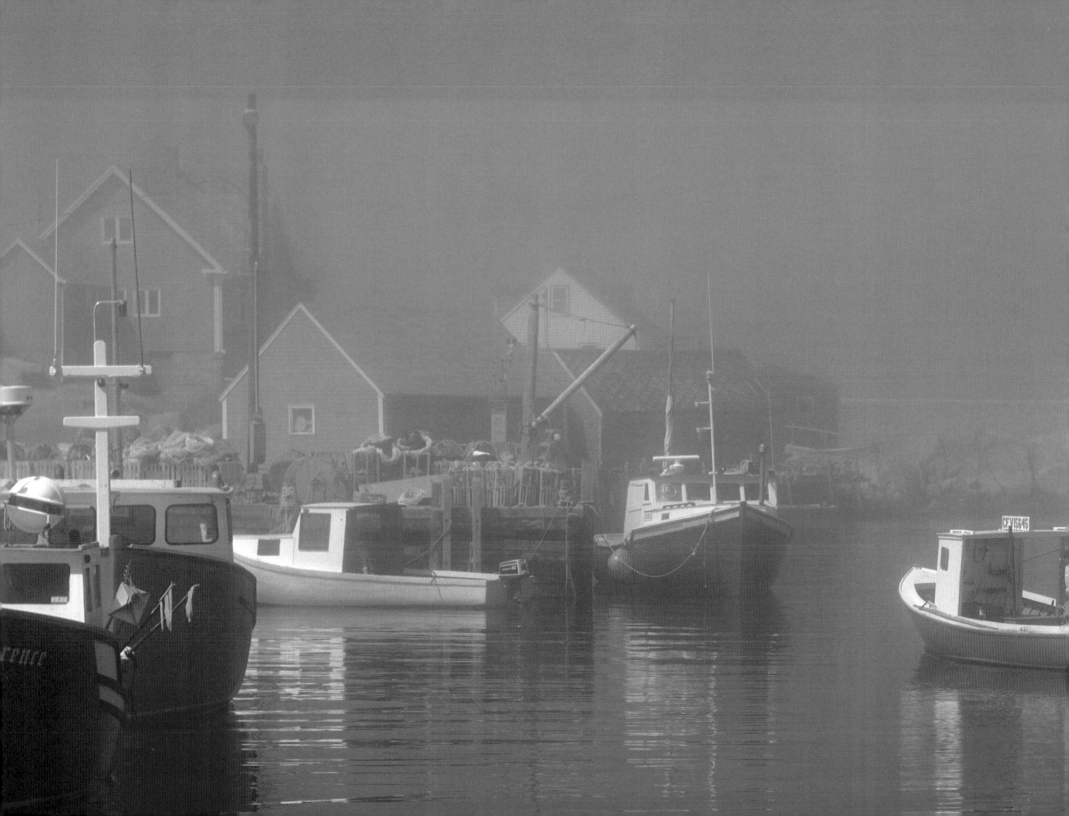

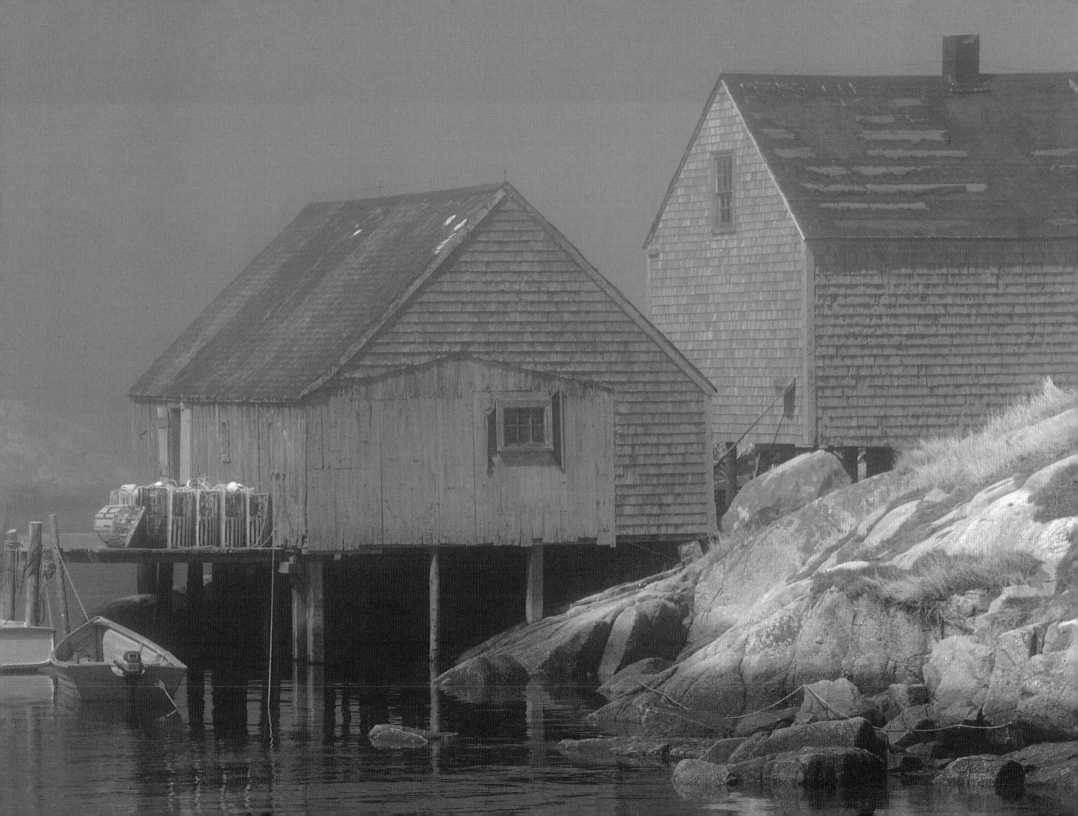

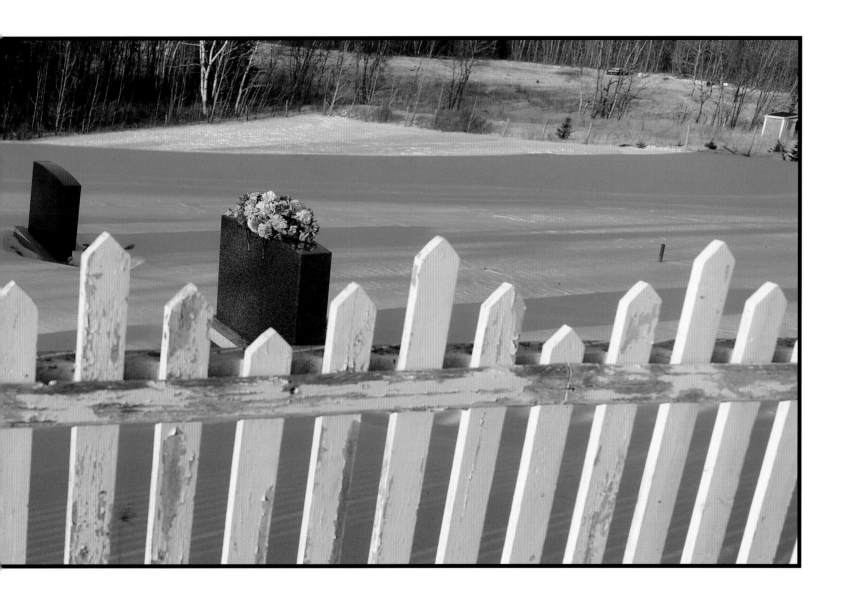

A county graveyard with seasonal
flowers, near Belmont.

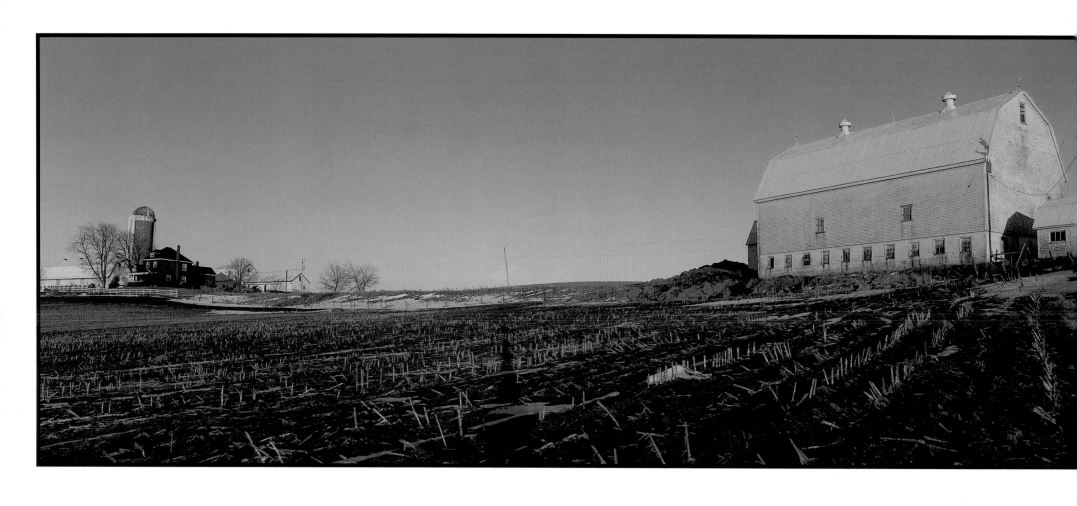

Eiklyn farm, Shubenacadie, home of a master breeder herd of Holstein cows.

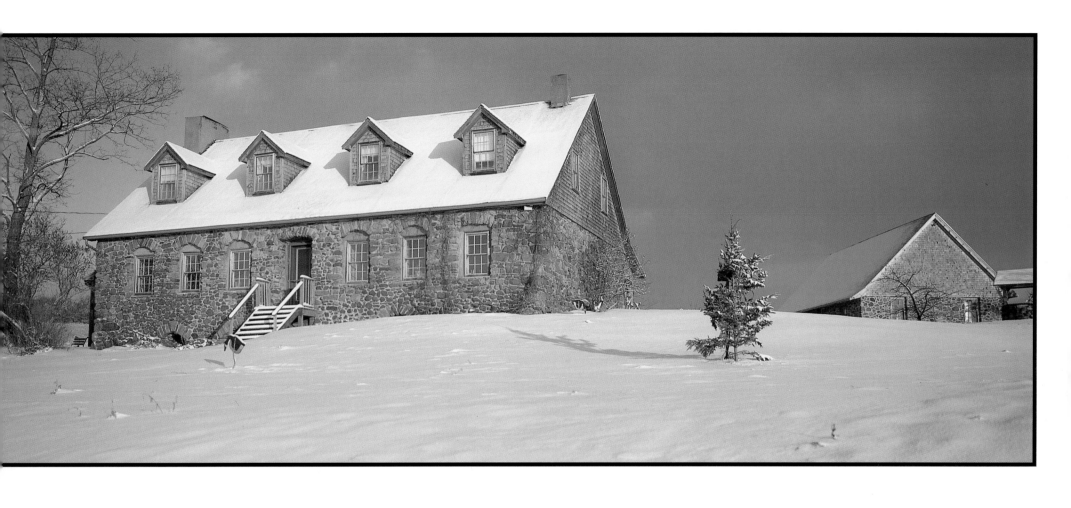

Known locally as the Old Stone House, in Poplar Grove. It was actually built in 1699 as the "Mission Shubenacadie," by the French.

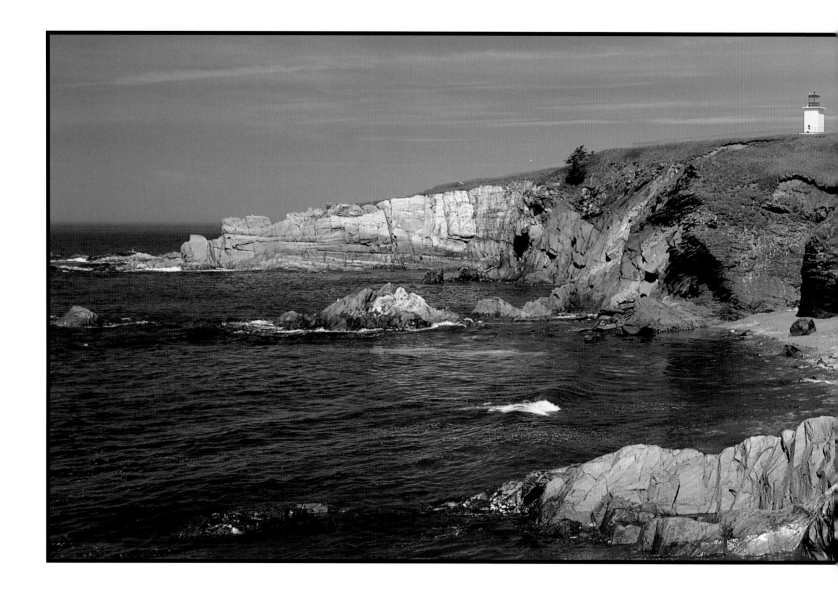

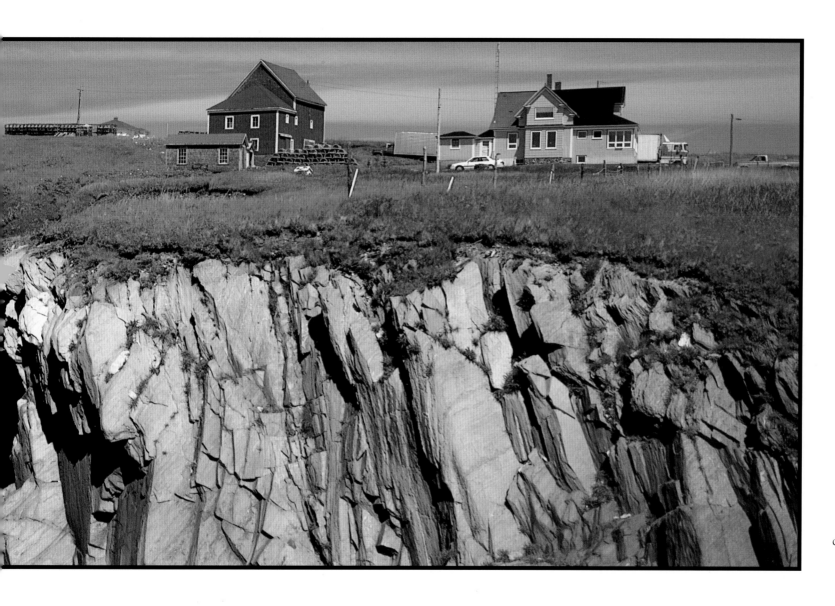

Cape St. Mary's is an exposed, rugged coastline faced with the weather from the Gulf of Maine.

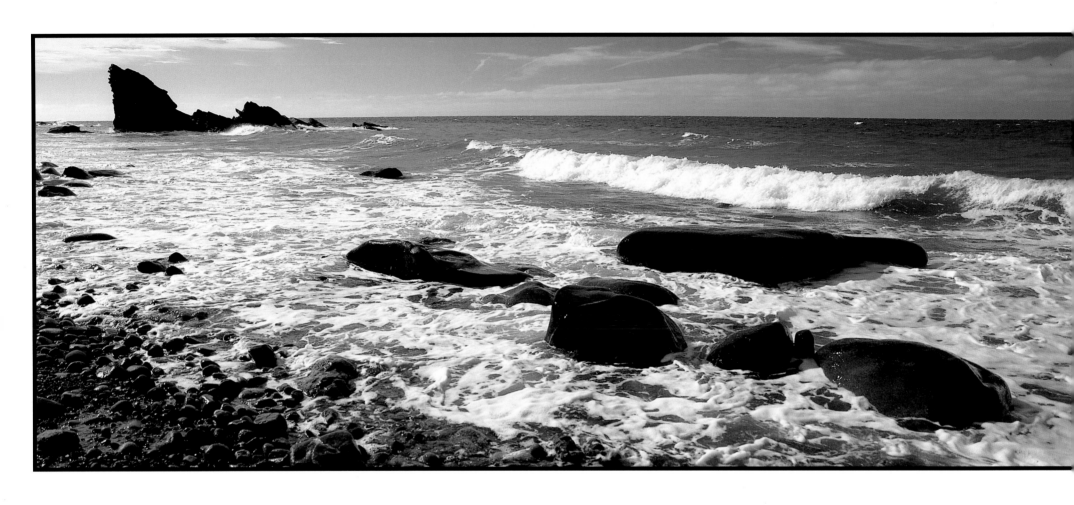

The shoreline north of Chéticamp at the beginning of the Cape Breton Highlands National Park.

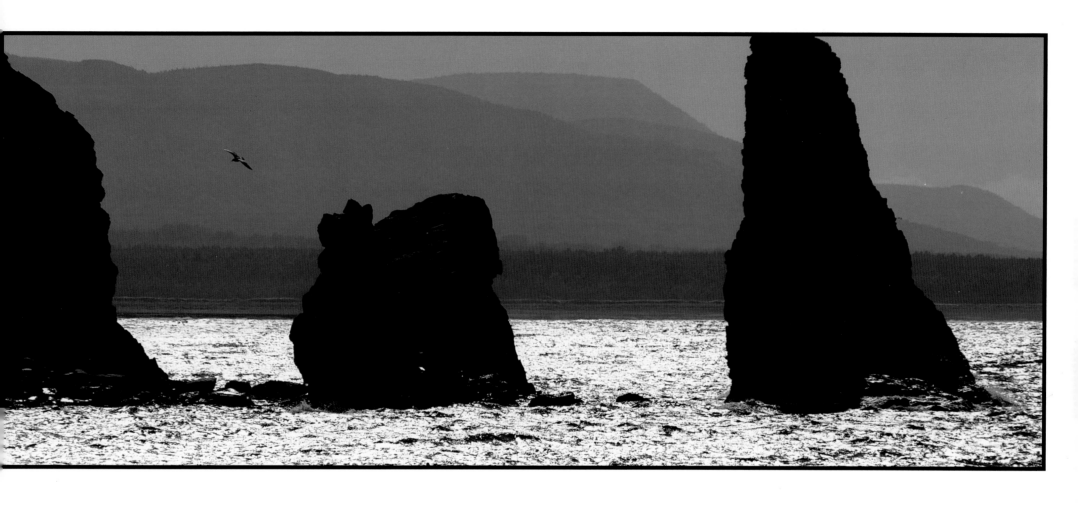

Rocks near Chéticamp along the Cabot Trail in Cape Breton.

Overleaf: Fish storage sheds along the Dublin shore.

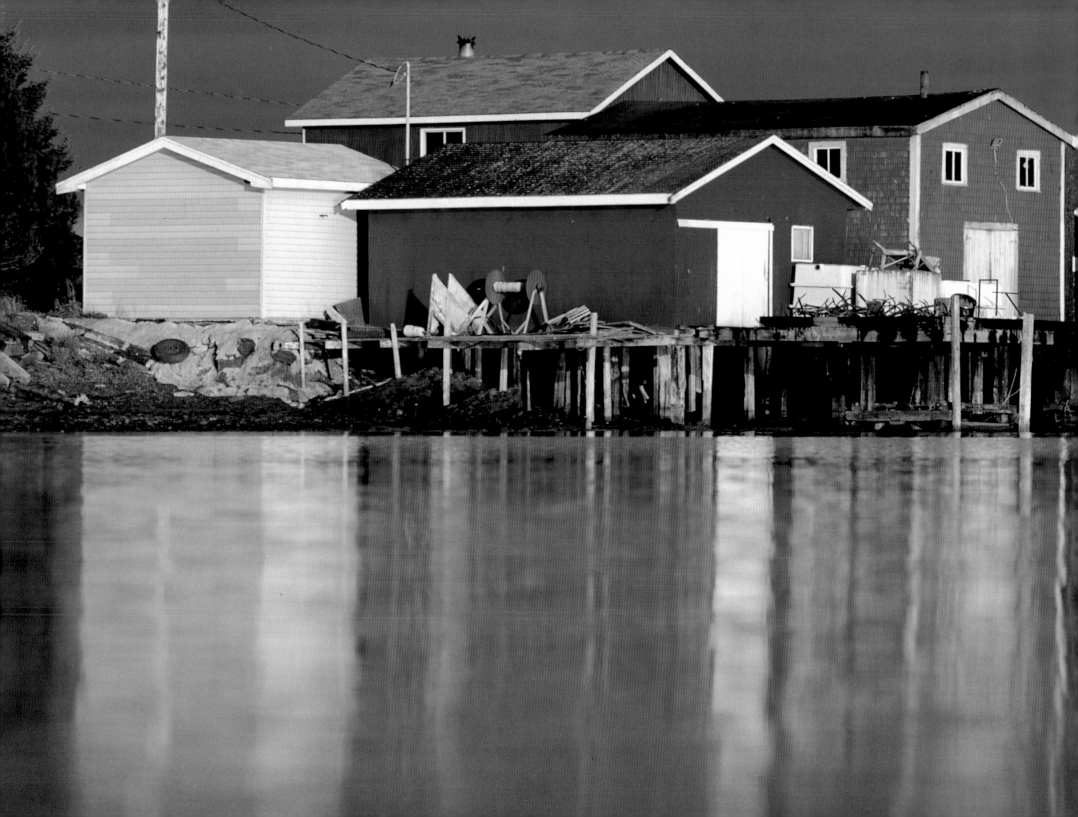

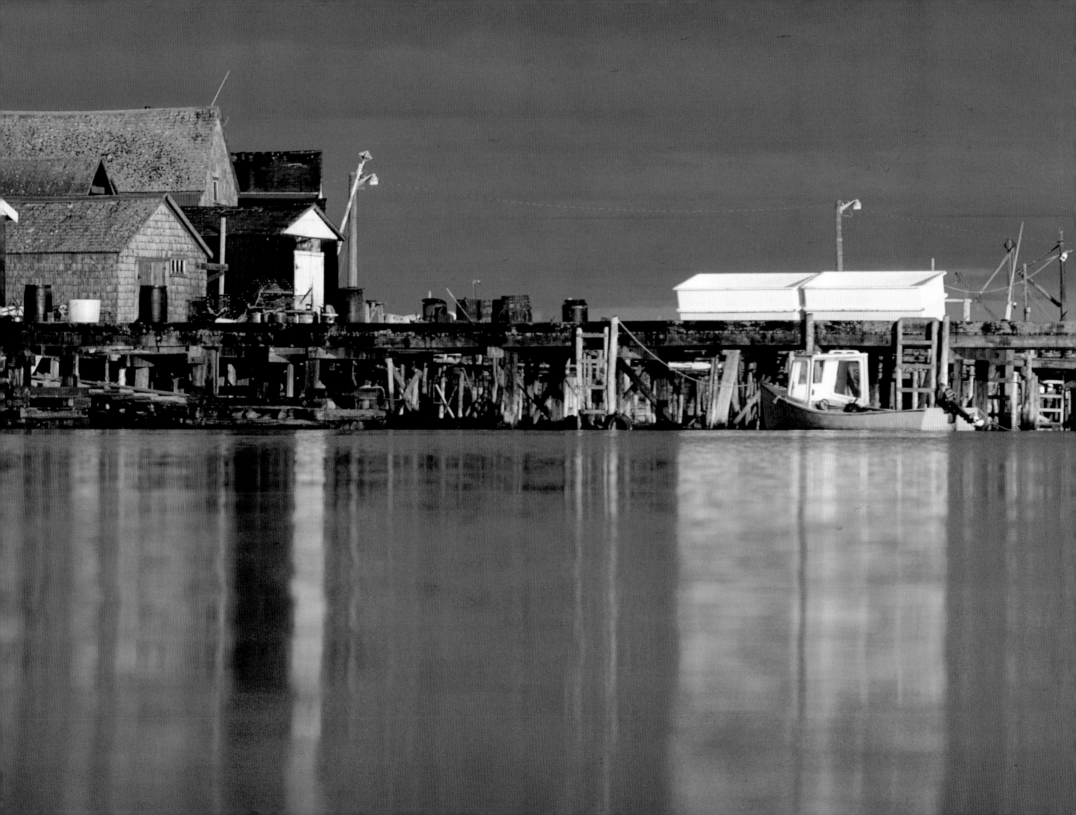

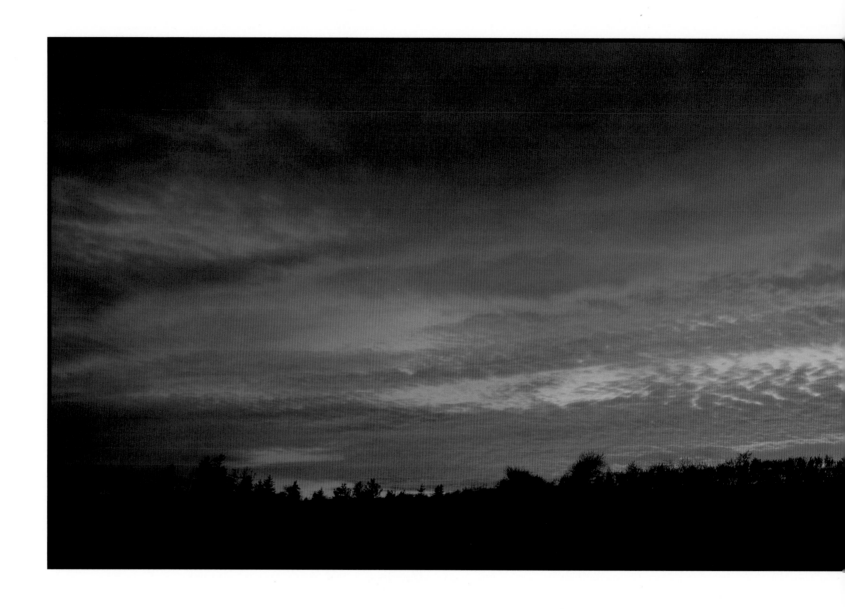

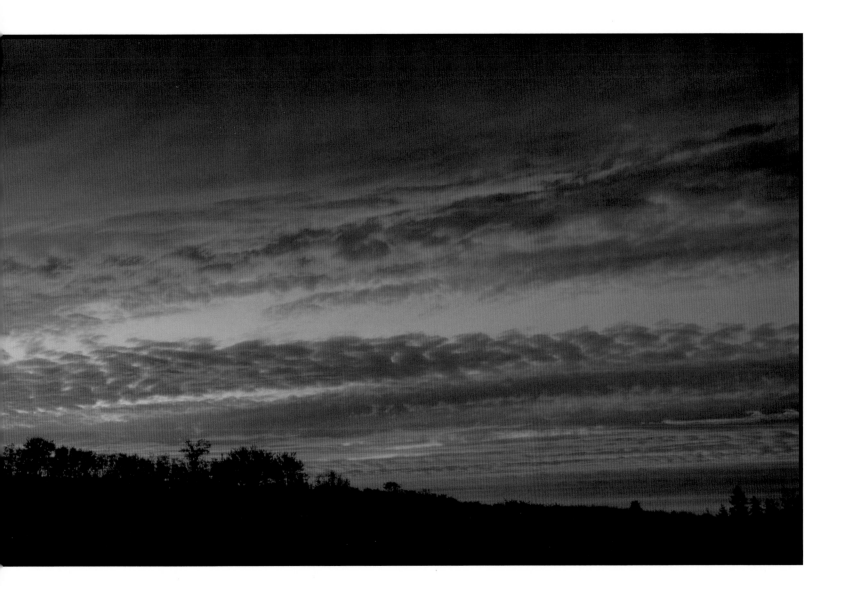

Sunsets are always a moment of glory.

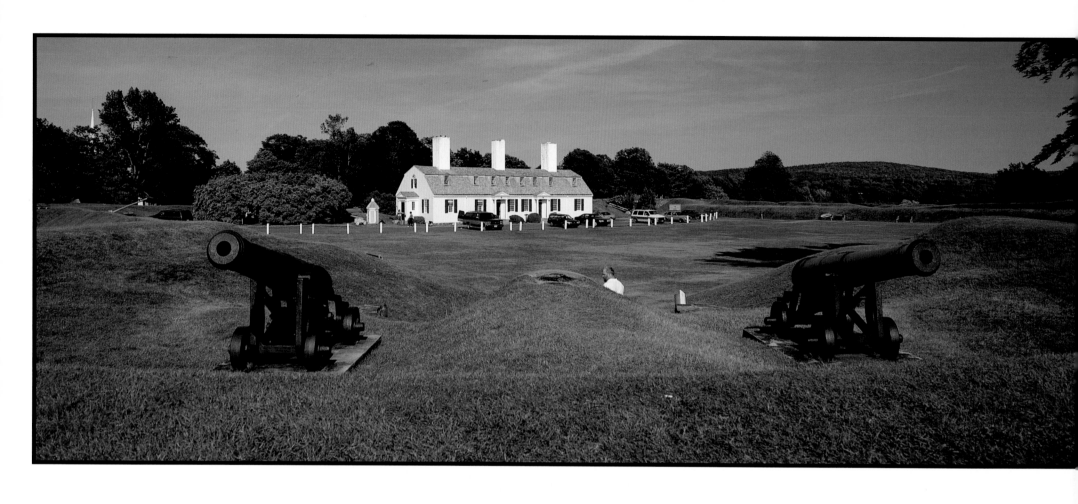

Fort Anne National Historic Park in the town of Annapolis Royal.

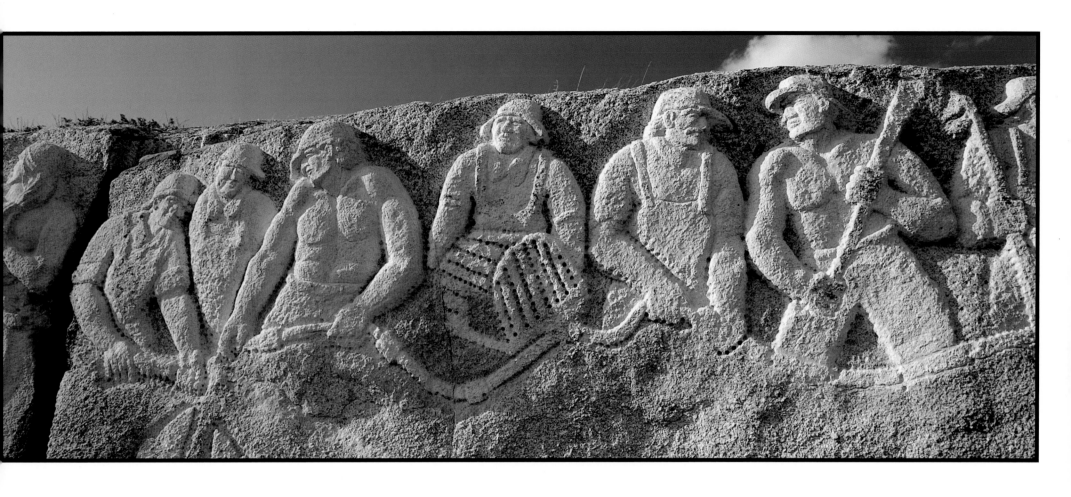

Artist William de Garthe's monument to the fishermen and their families of Peggy's Cove.
Ten years in the making, the granite sculpture has thirty different figures.

Overleaf: The harbour at Liverpool on a rare becalmed day. In the background is the Bowater Mersey
Paper Co. Ltd., of Brooklyn.

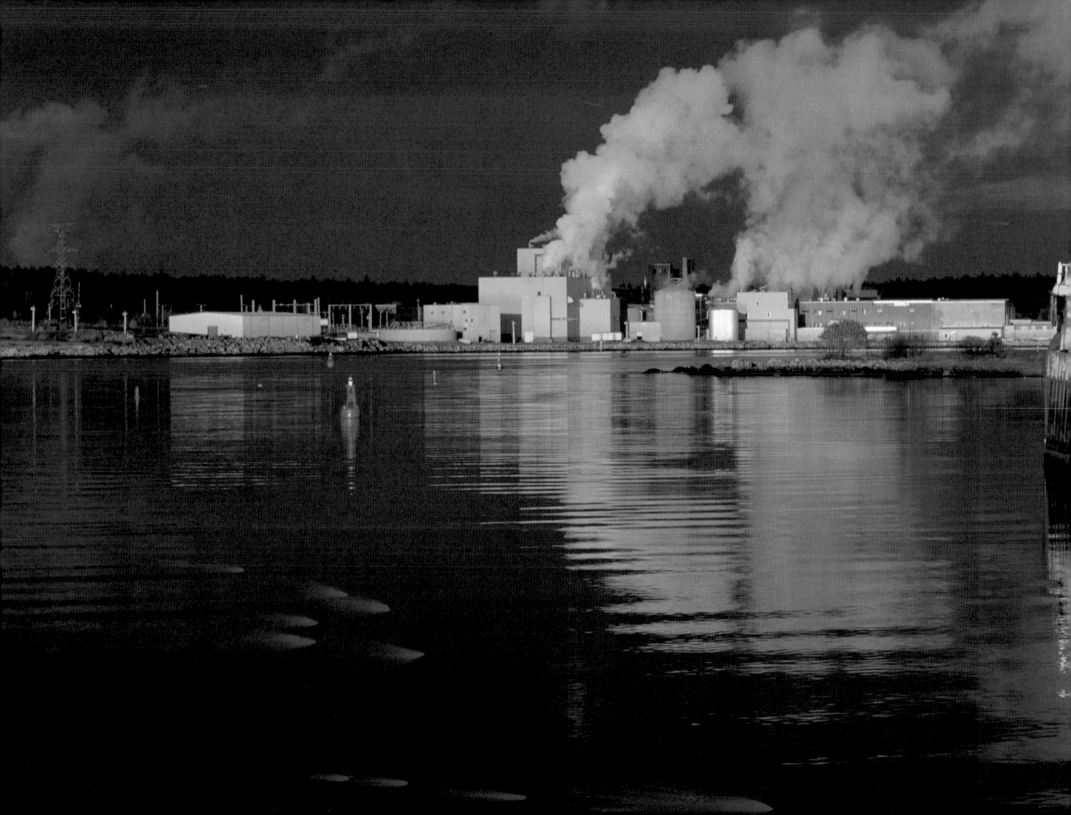

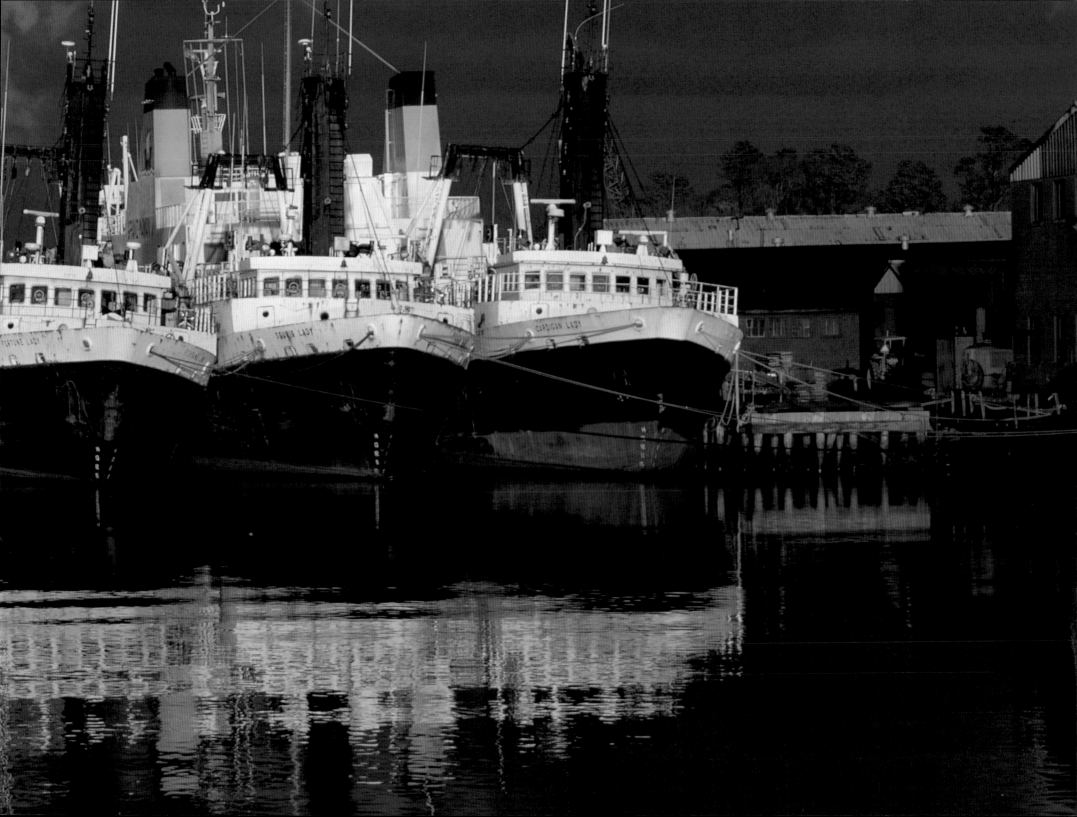

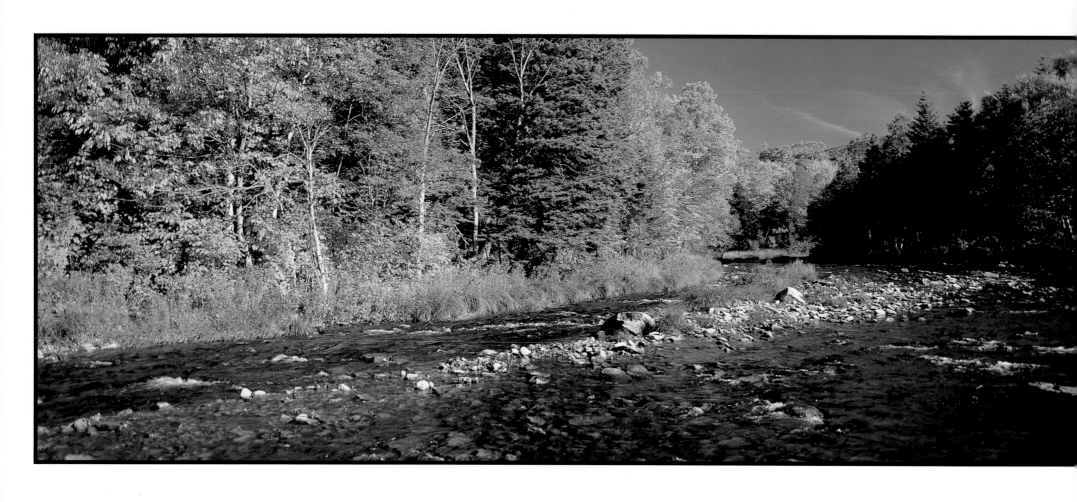

The Margaree Valley, Cape Breton, ablaze with Fall colour.

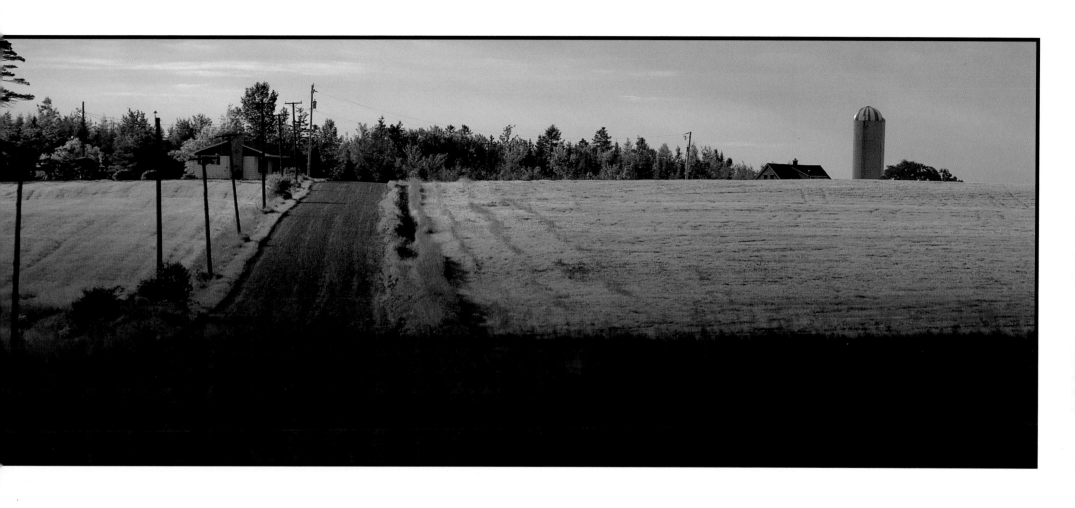

Farm silos and country roads in the Truro area.

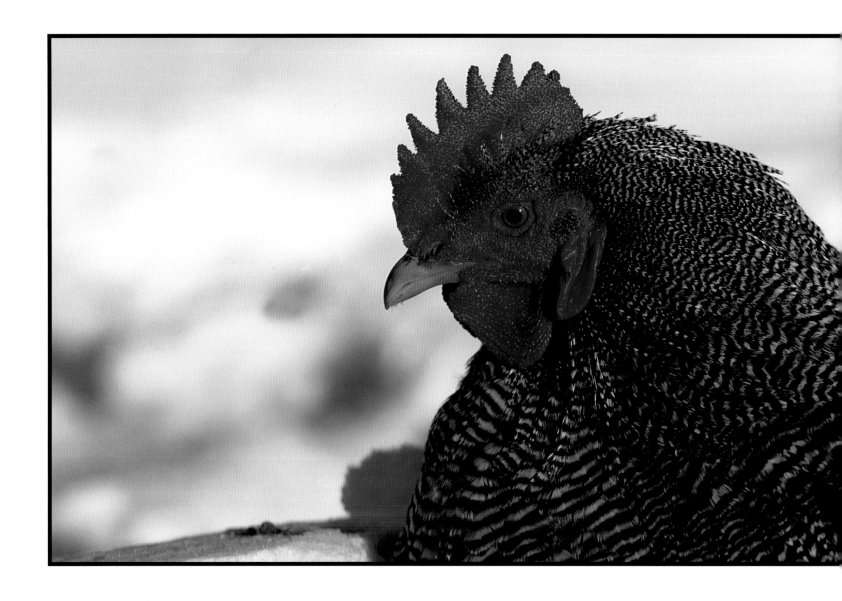

Free-range chicken, Parrsboro.

Overleaf: Blue Rocks near Lunenburg,
named after the ledges of blue slate rock.

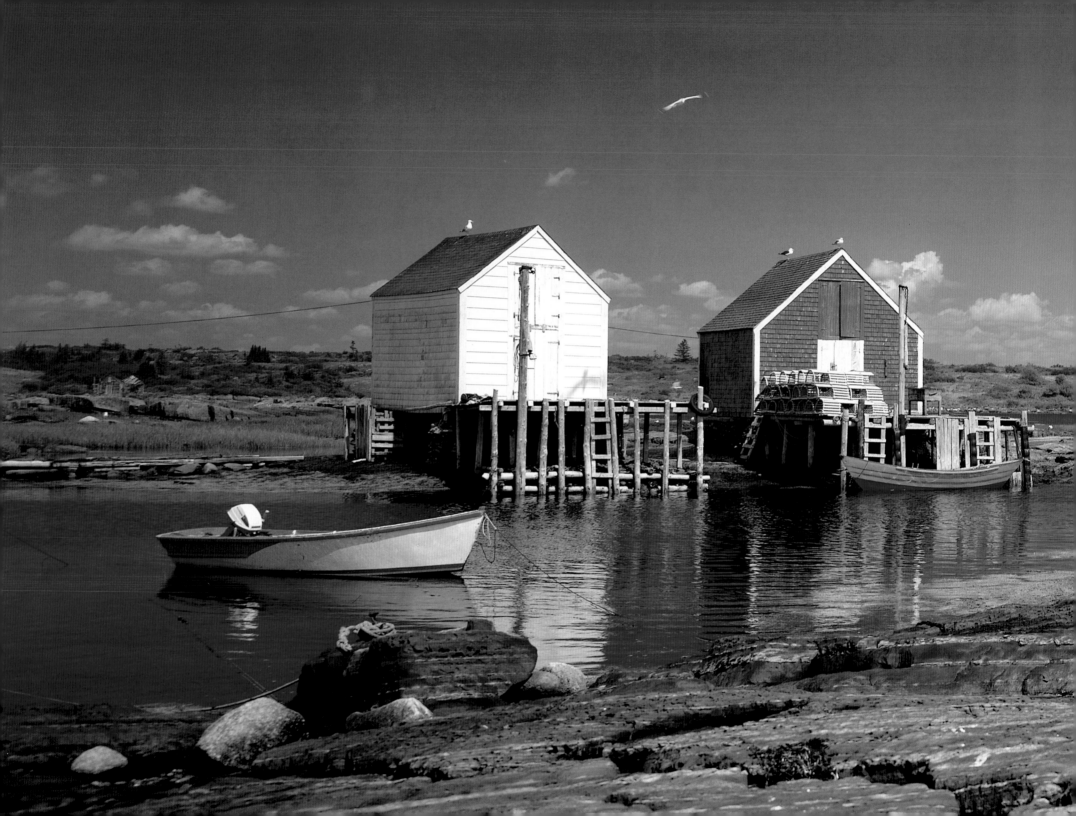

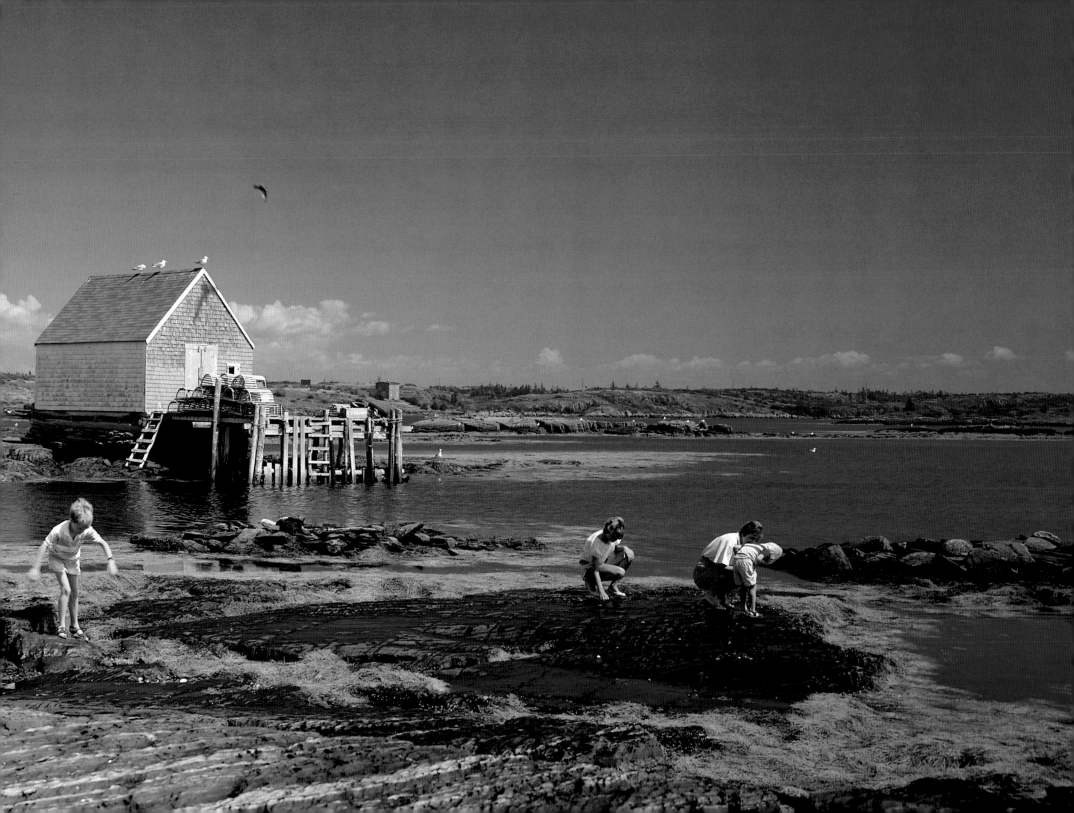

Fall colour along the Glooscap Trail.

Fall Harvest in the Annapolis Valley.

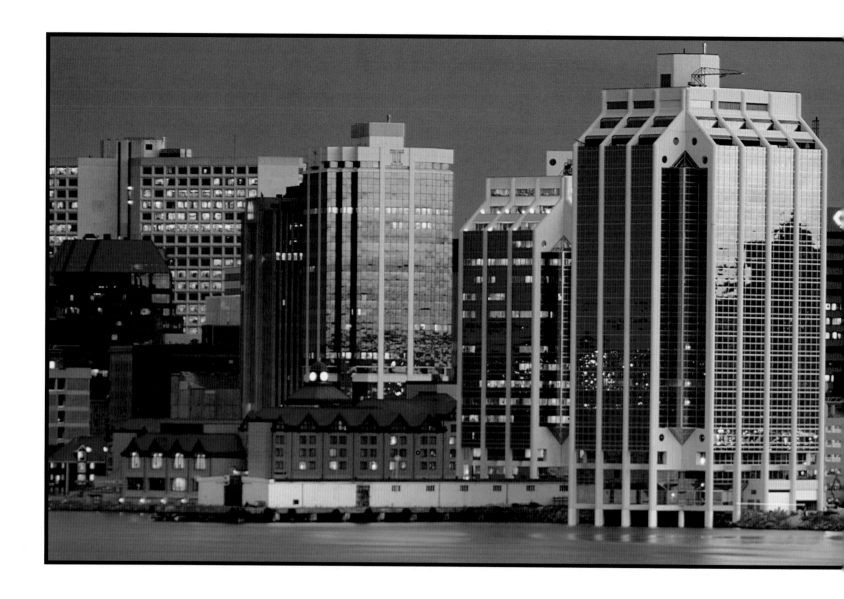

Halifax Harbour is world class with its
very deep water and two container
shipping piers.

A salmon fisherman tries his luck in the North East Margaree River, Cape Breton.

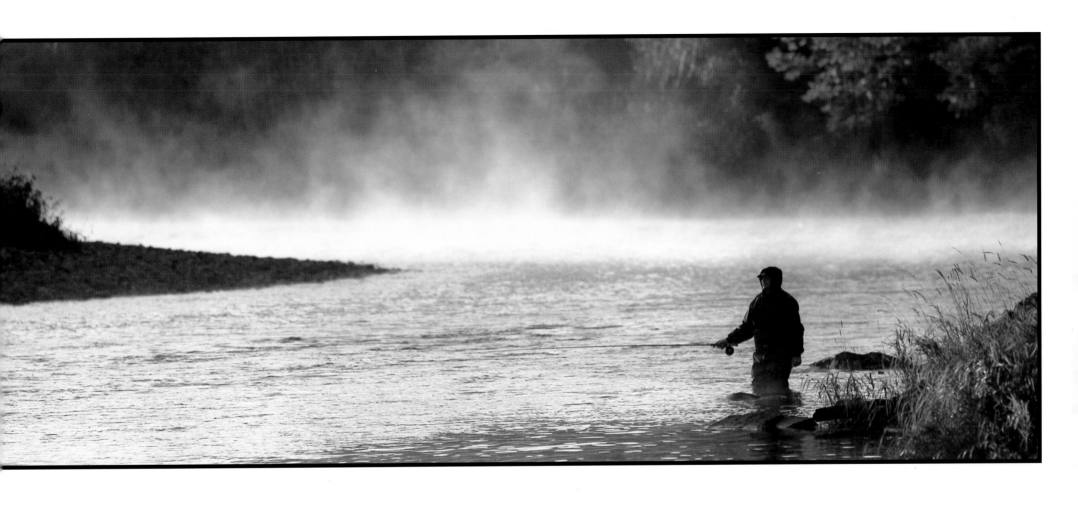

Early morning mist and the challenge of salmon, in Cape Breton.

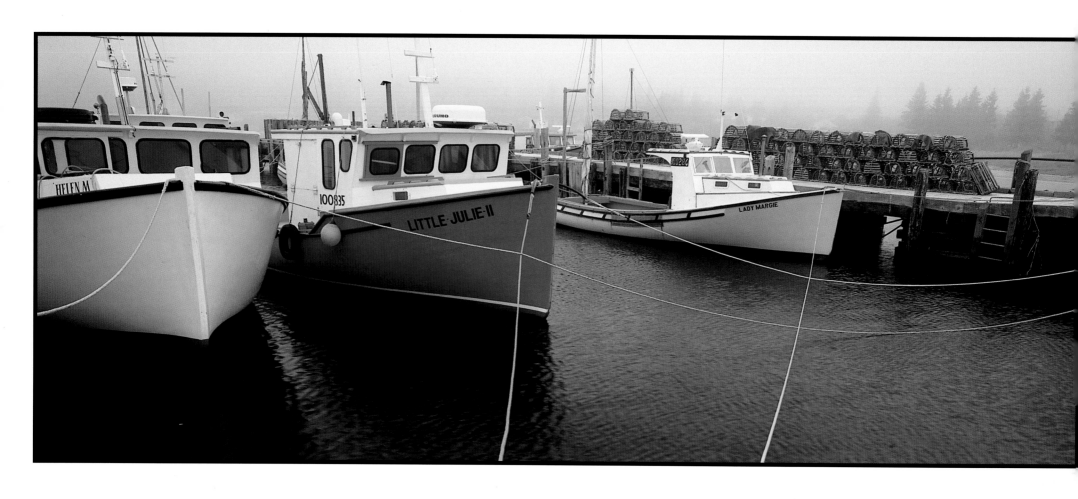

Cape Island-style boats at the Hunts Point Wharf.

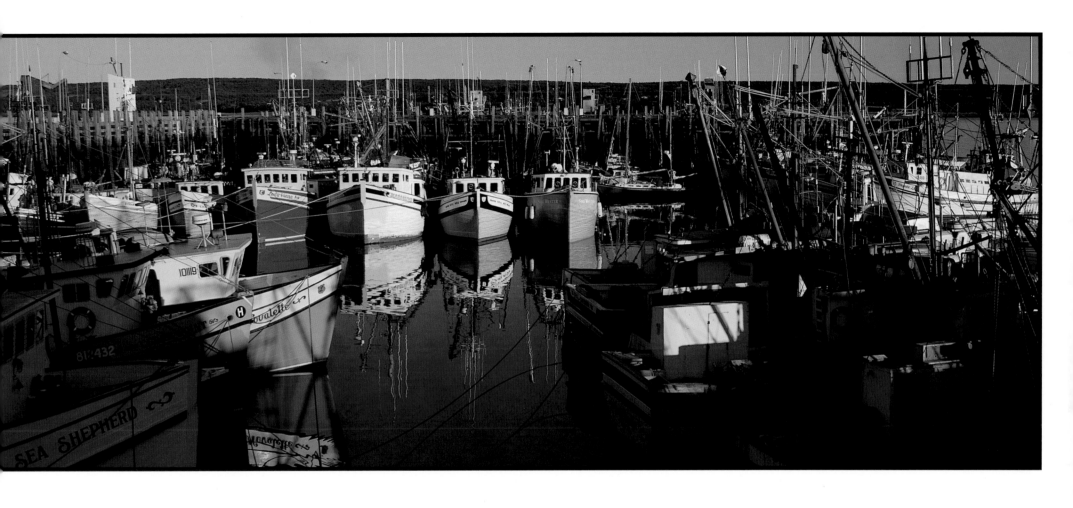

Weymouth, Yarmouth, Pubnico and boats from other ports crowd this harbour
in the south-west area of Nova Scotia.

Overleaf: The rugged shore of St. George's Bay near Cape George.

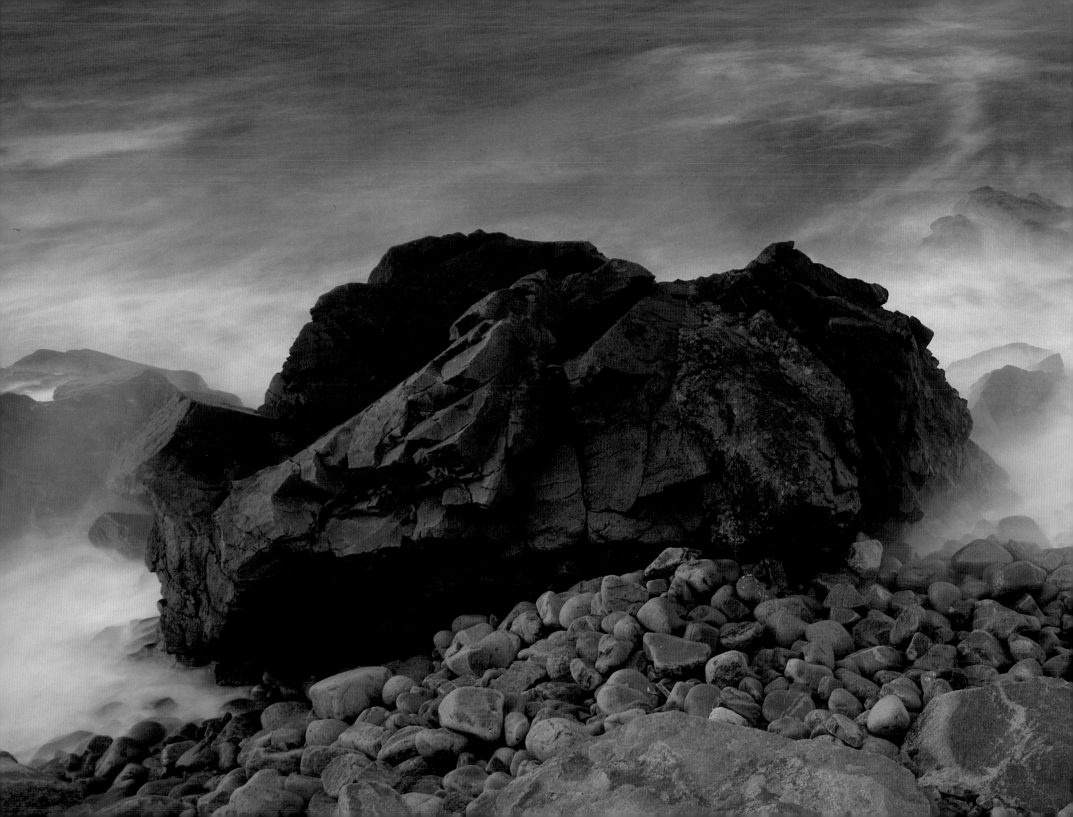

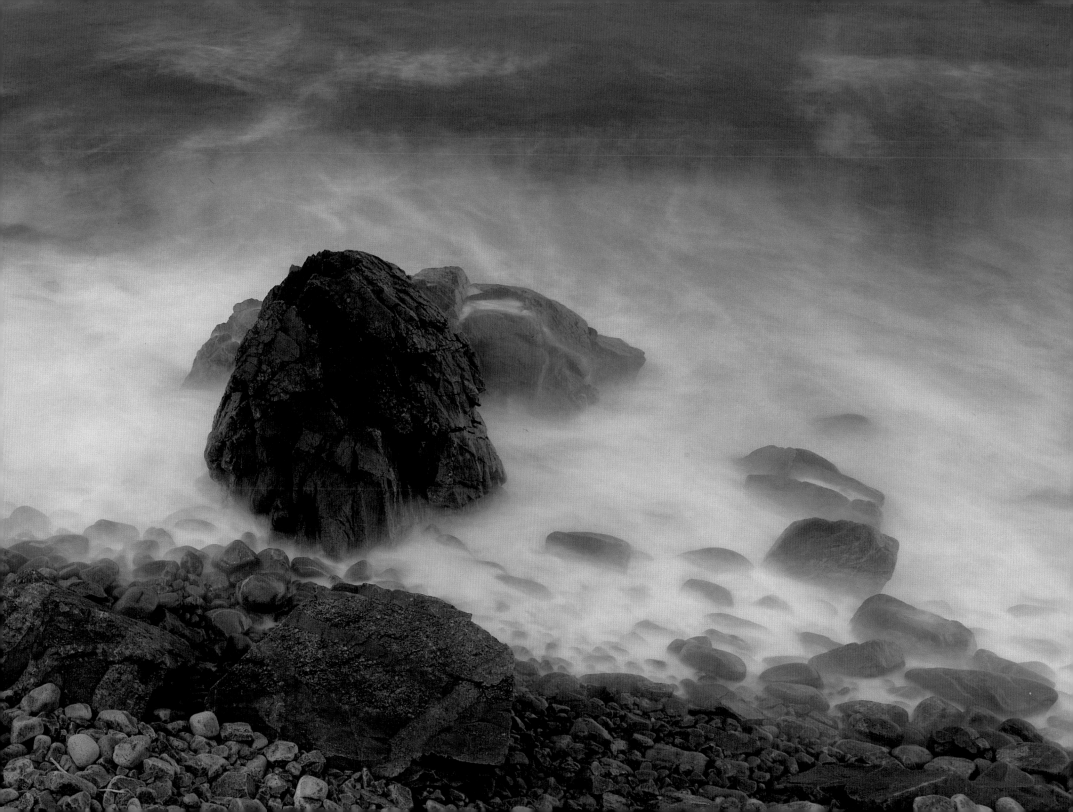

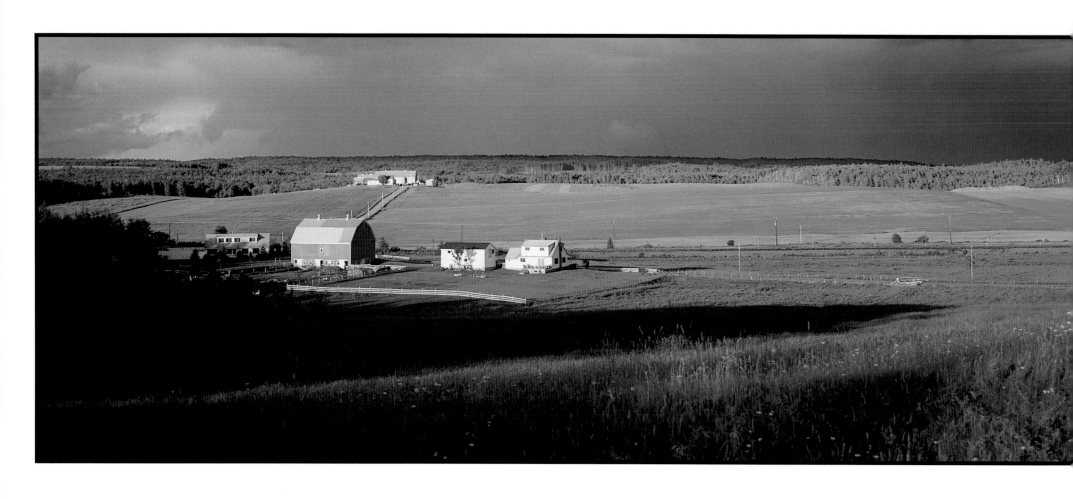

Hilden, near Truro has very picturesque farms. This one is viewed from the Trans Canada Highway.

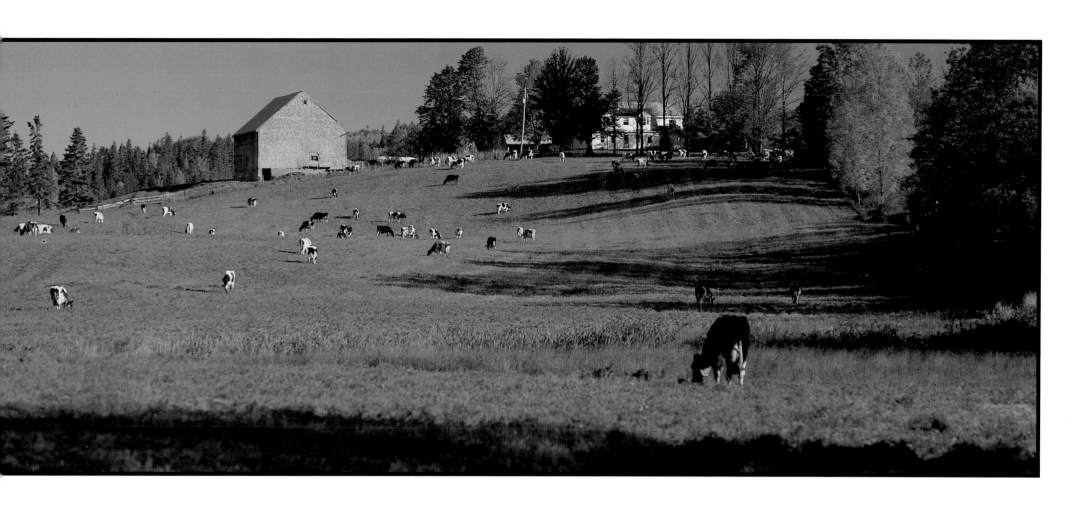

The Shaw farm in Ferry Road.

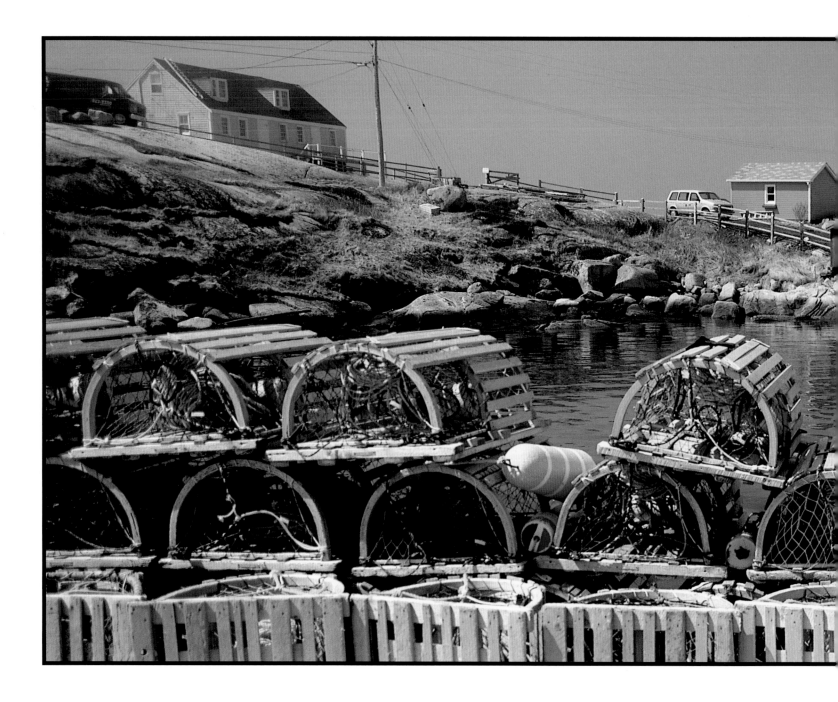

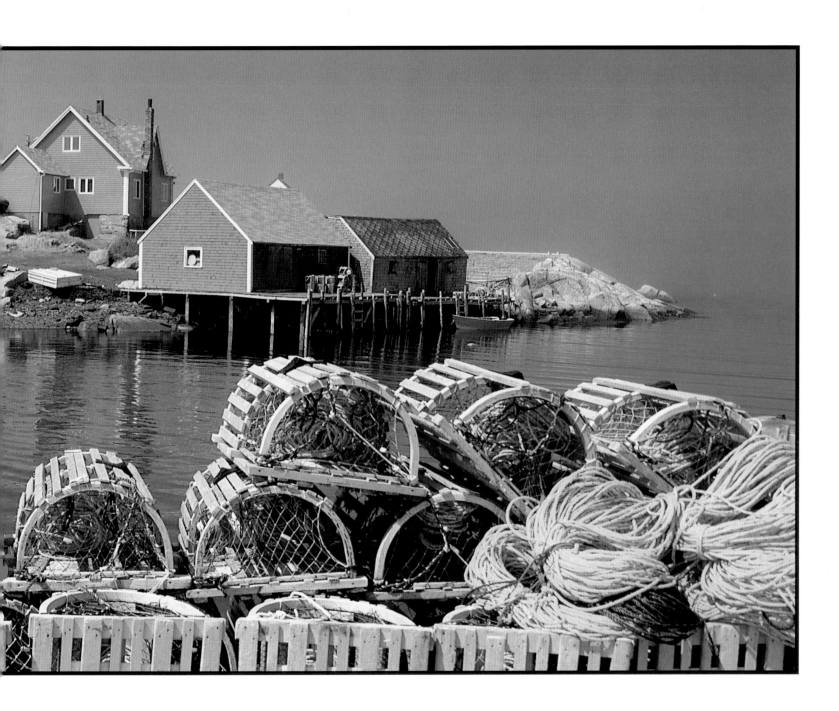

Peggy's Cove, ready for the lobster
fishing season.

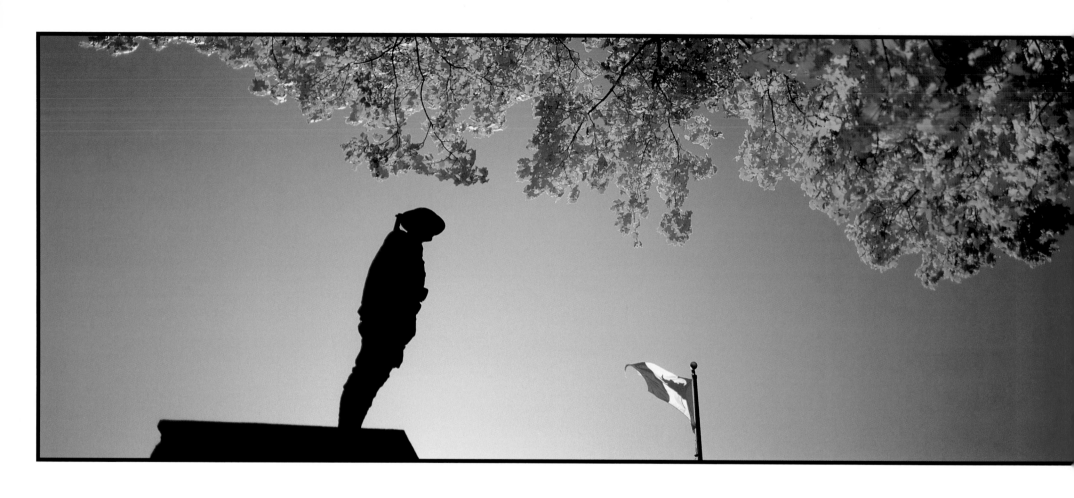

Wolfville War Memorial.

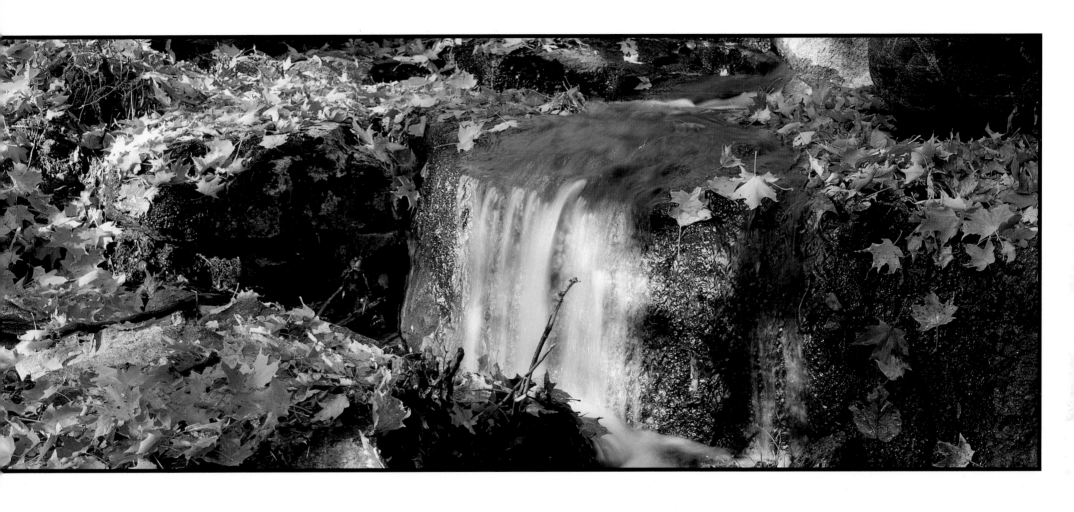

Maple leaves, from Yarmouth to the Cabot Trail in late October.

Overleaf: The patterns of farming near Canning in the Annapolis Valley.

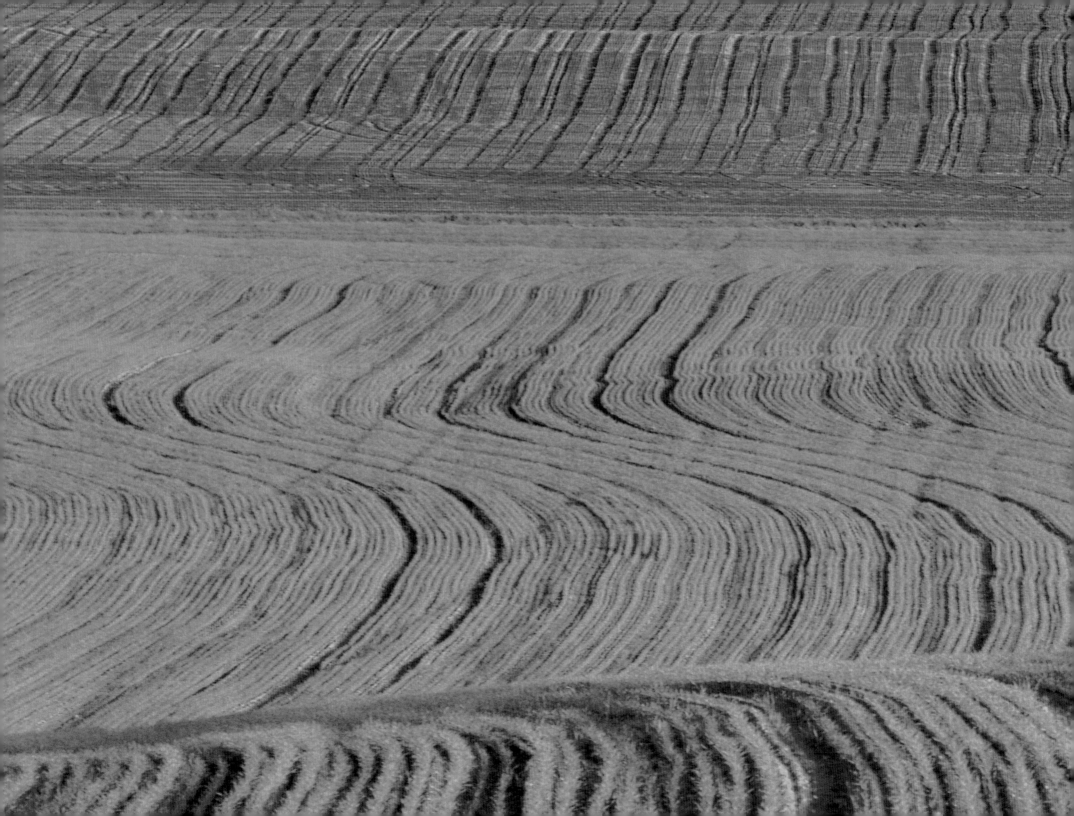

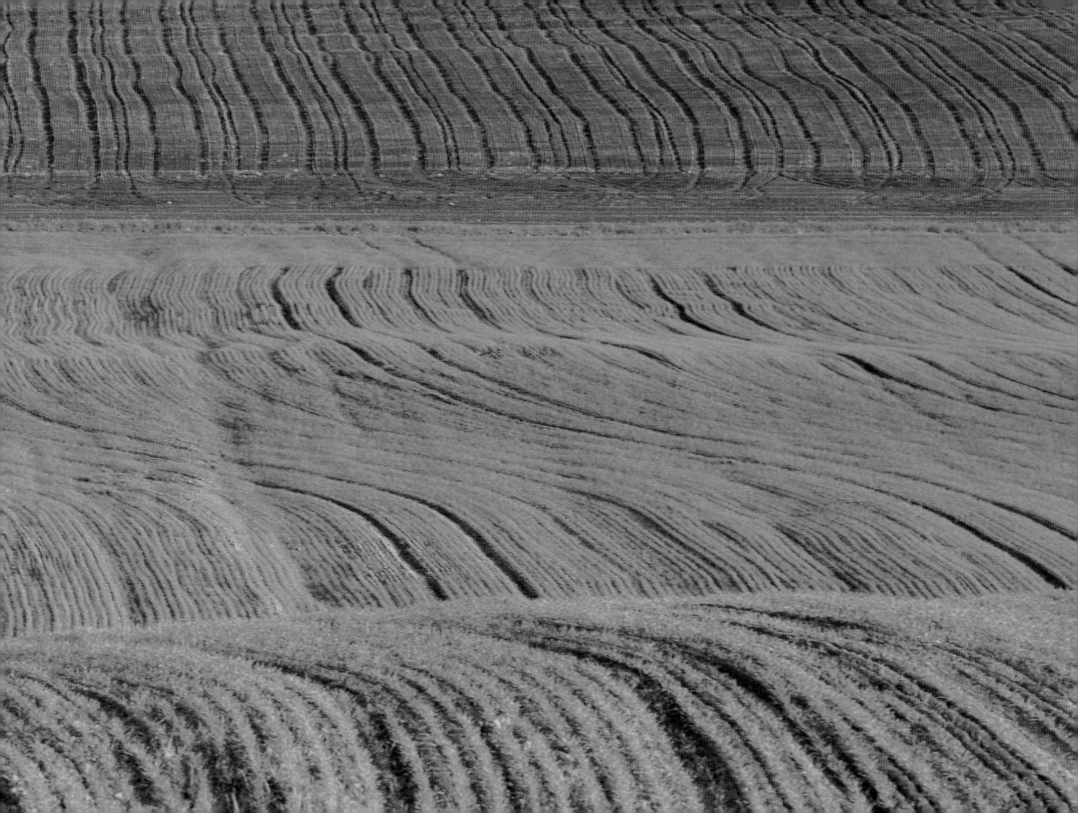

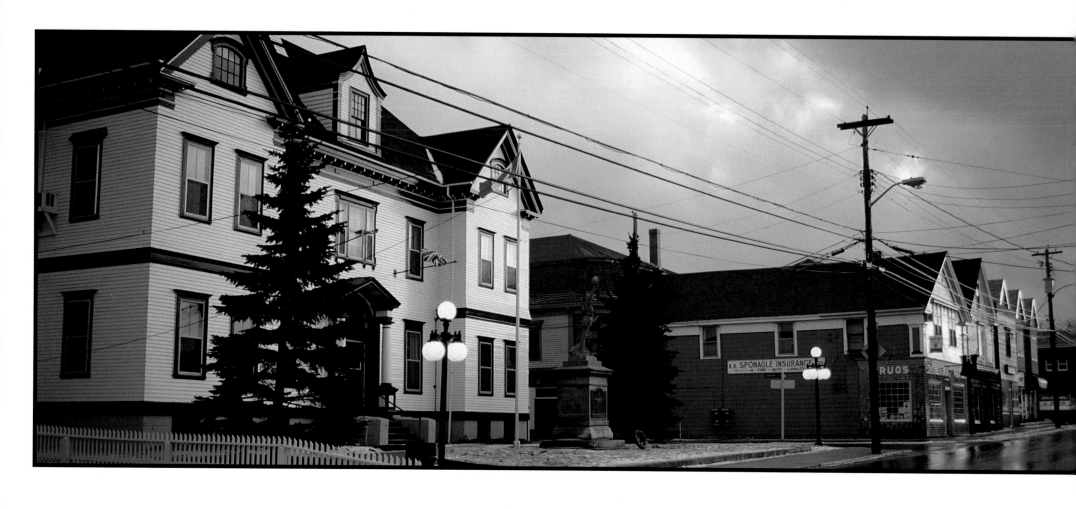

The Sherman Hines Photography Museum and Gallery, Liverpool, located in the Old Town Hall.

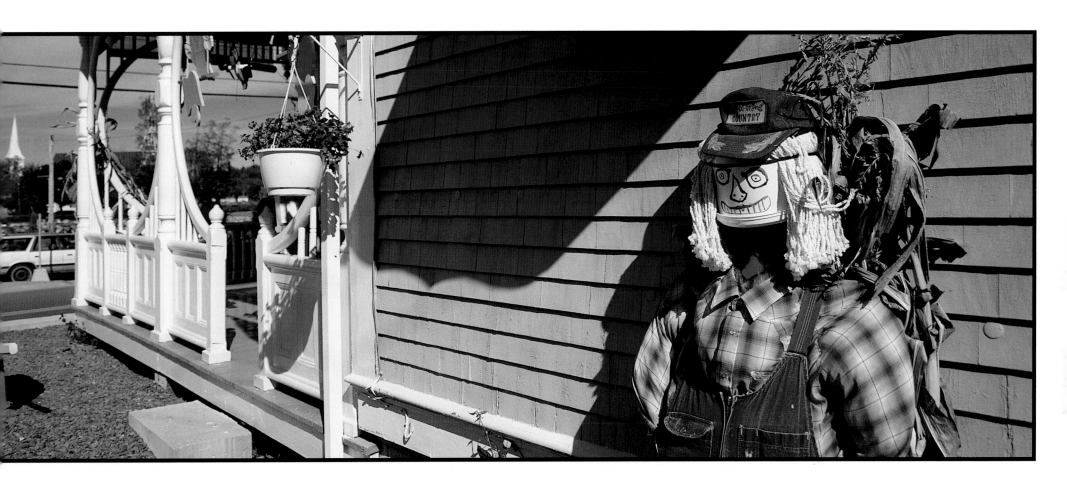

Scarecrow Festival, Mahone Bay.

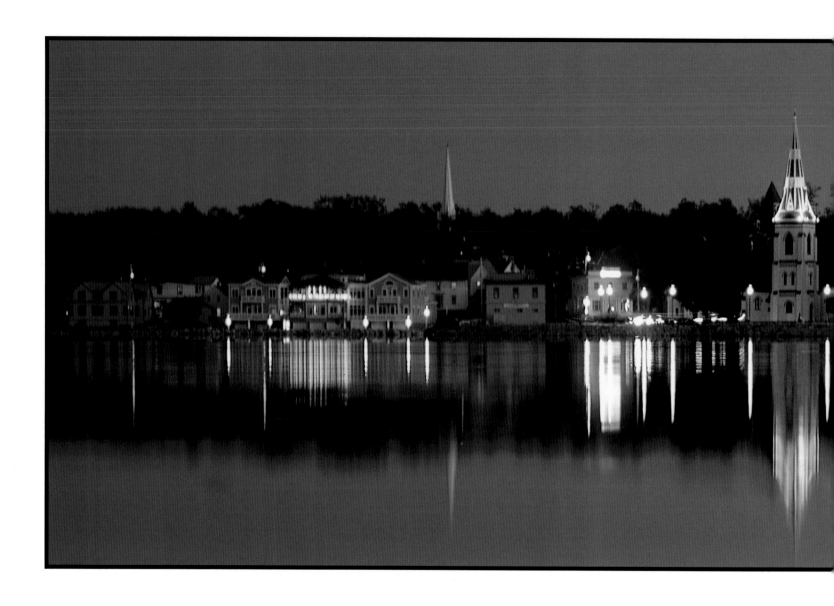

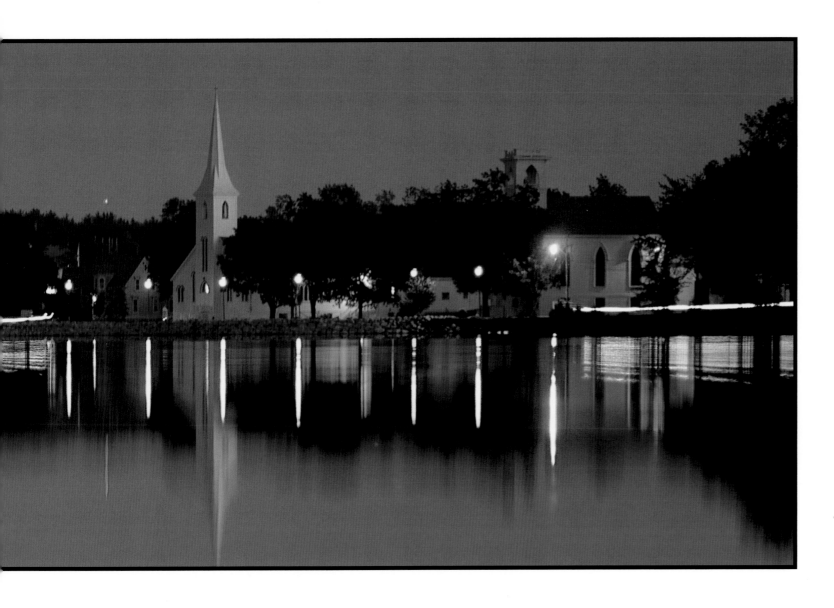

The churches of Mahone Bay Harbour,
reflecting the lights
and buildings.

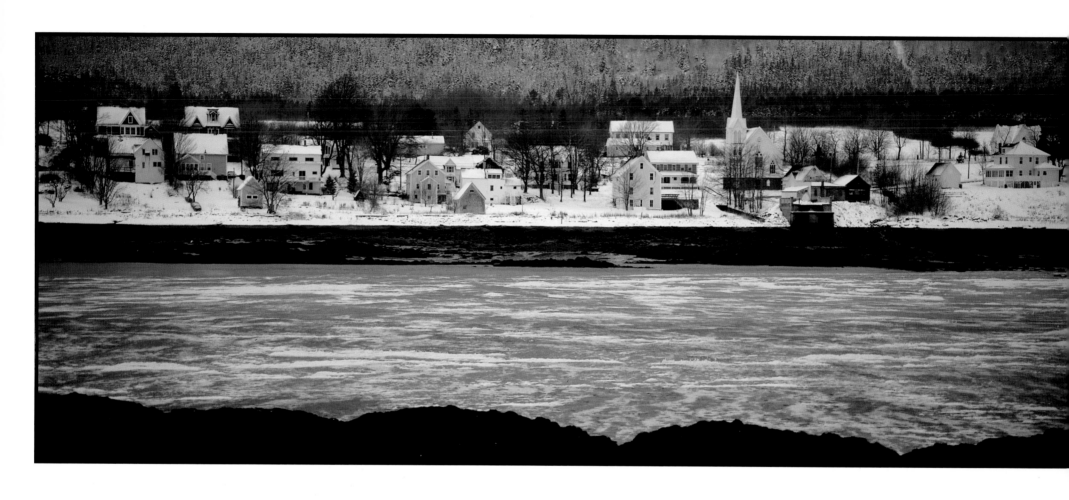

Granville Ferry, across the Annapolis River.

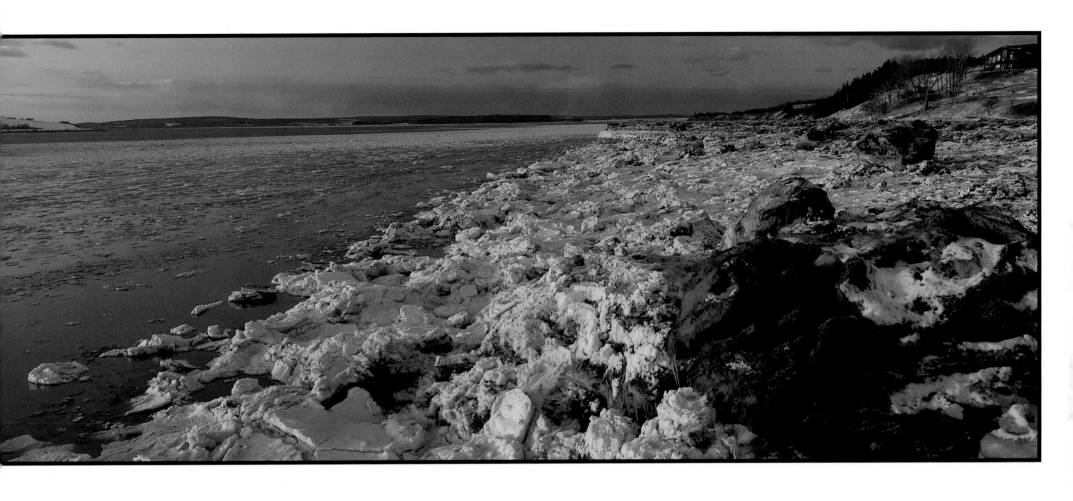

The Avon River empties into the Minas Basin where it becomes a tidal river. Winter creates a very different look to the shoreline, icebergs of brown mud.

Overleaf: Shelburne waterfront, rebuilt as a movie set.

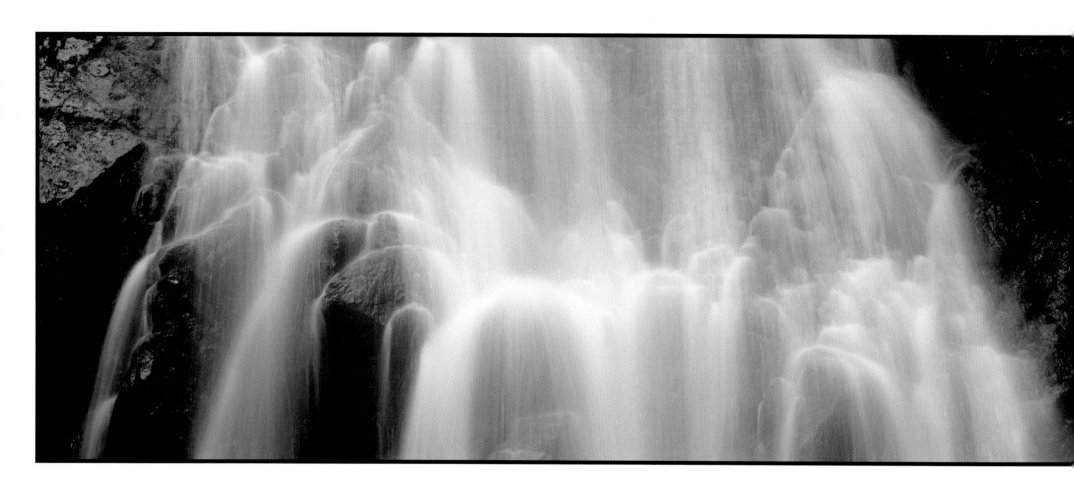

Cape Breton has dozens of waterfalls and brooks.

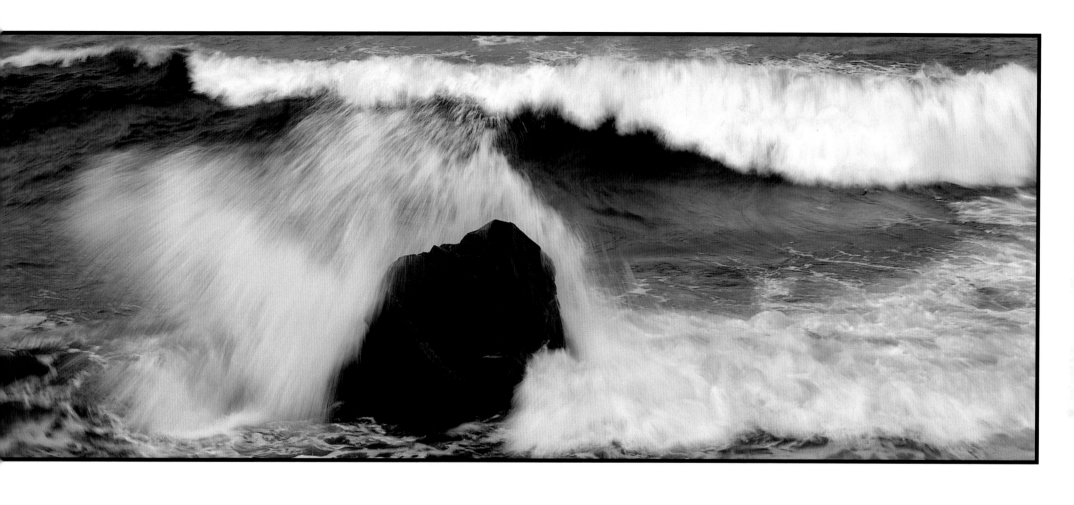

Surf provides an endless challenge for photographers to freeze the action or show
the movement, and create a mood.

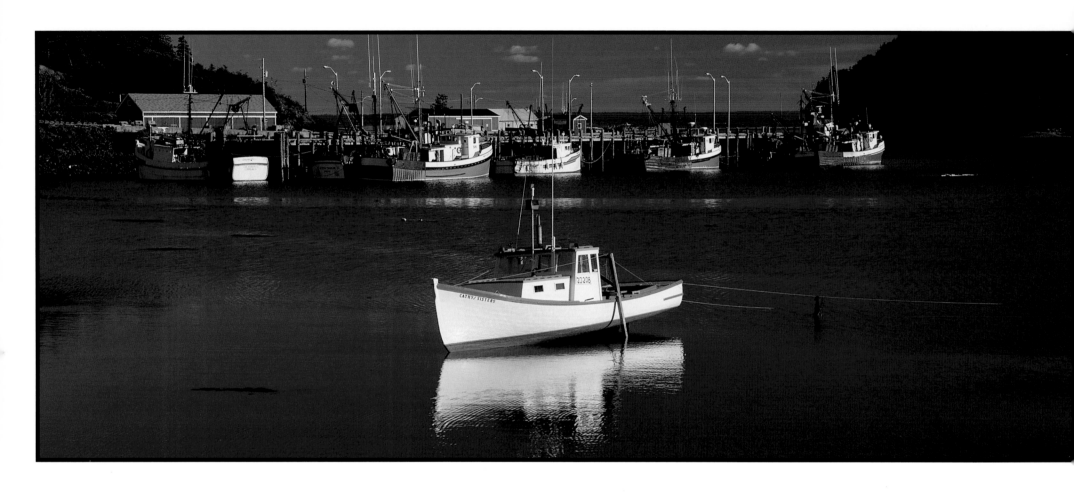

The fishing boats of Sandy Cove are left high and dry because of the extreme tides of the Bay of Fundy.

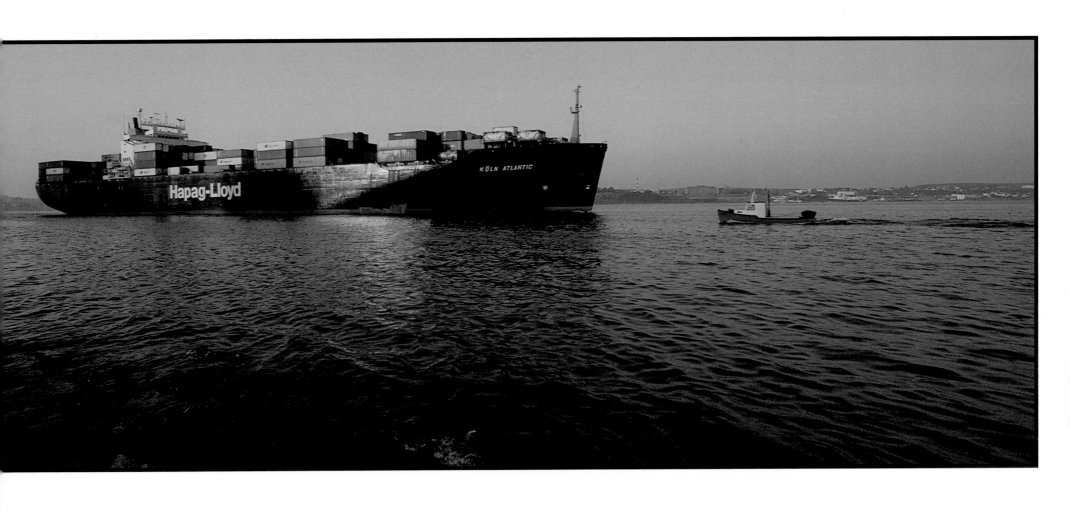

The *Köln Atlantic* container ship leaves Halifax Harbour.
An inland fishing boat is dwarfed by this huge ship.

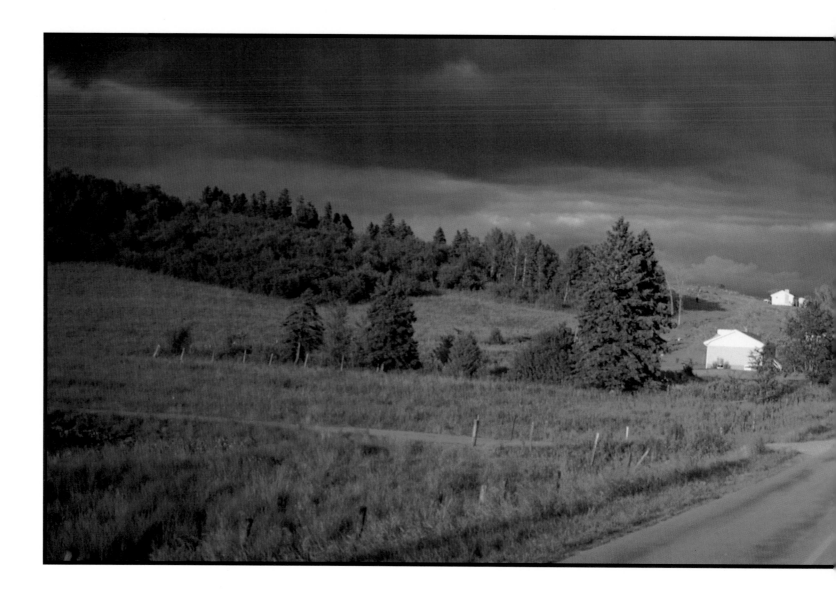

Country roads provide great photographic subjects.

Overleaf: Glen Haven Cove along the coast of St. Margaret's Bay.

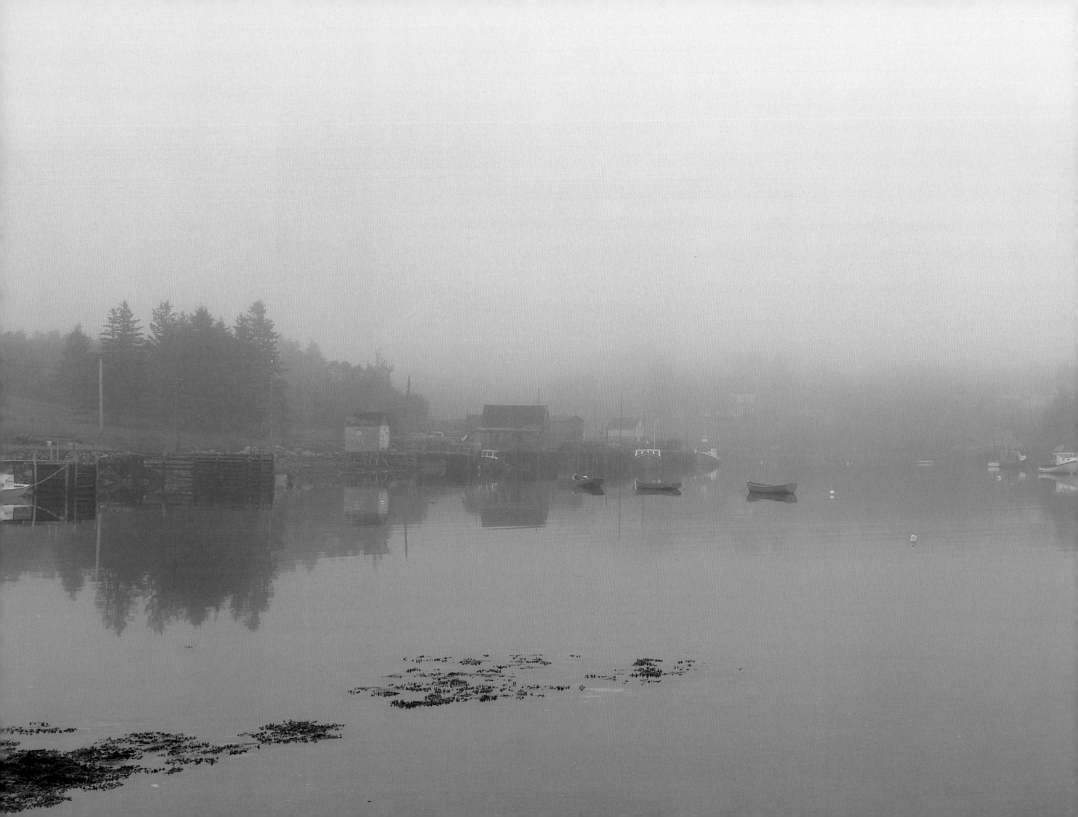

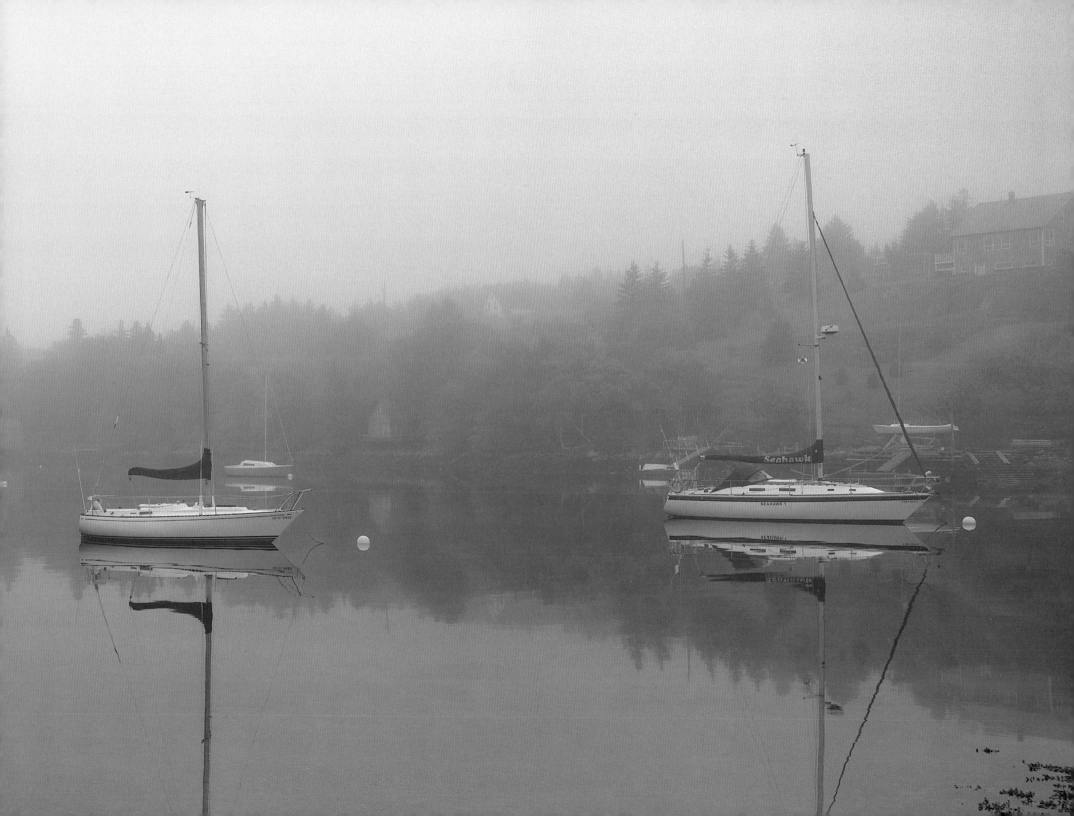

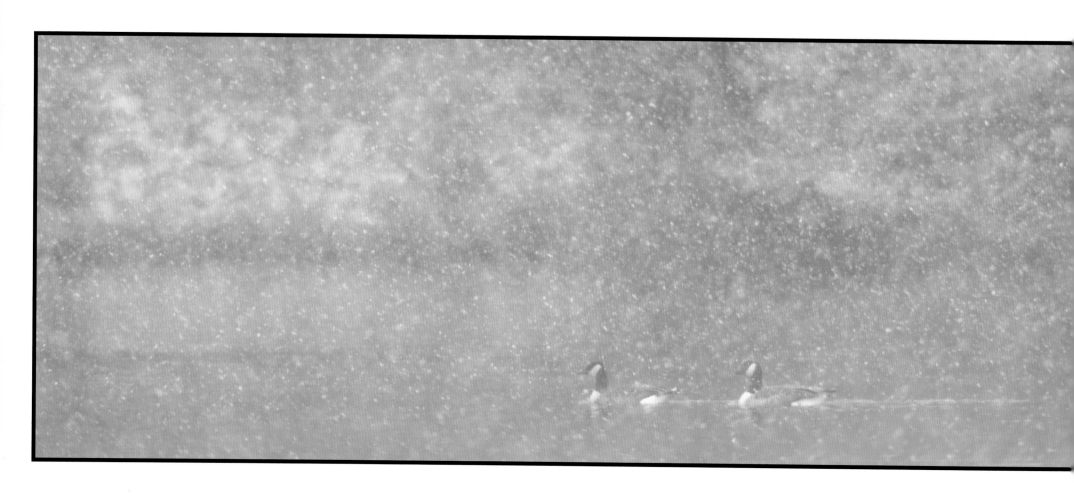

Snowflakes and Canada Geese are both found in early Fall in Nova Scotia.

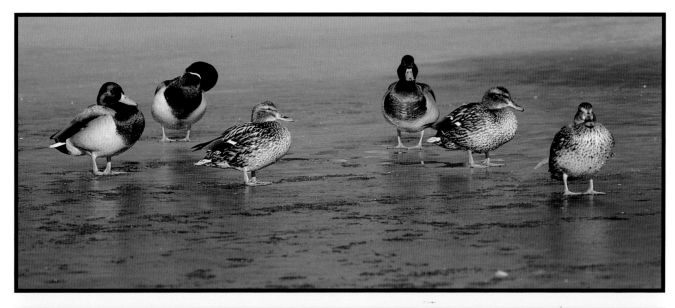

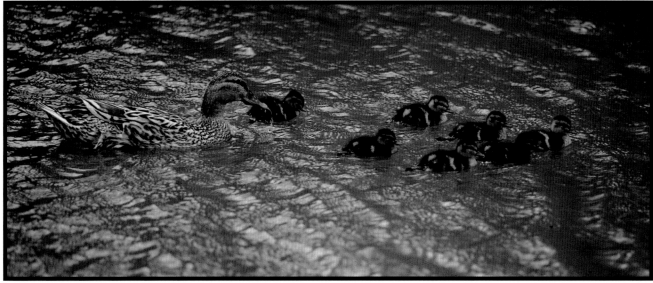

Winter and Spring at the Halifax Public Gardens.

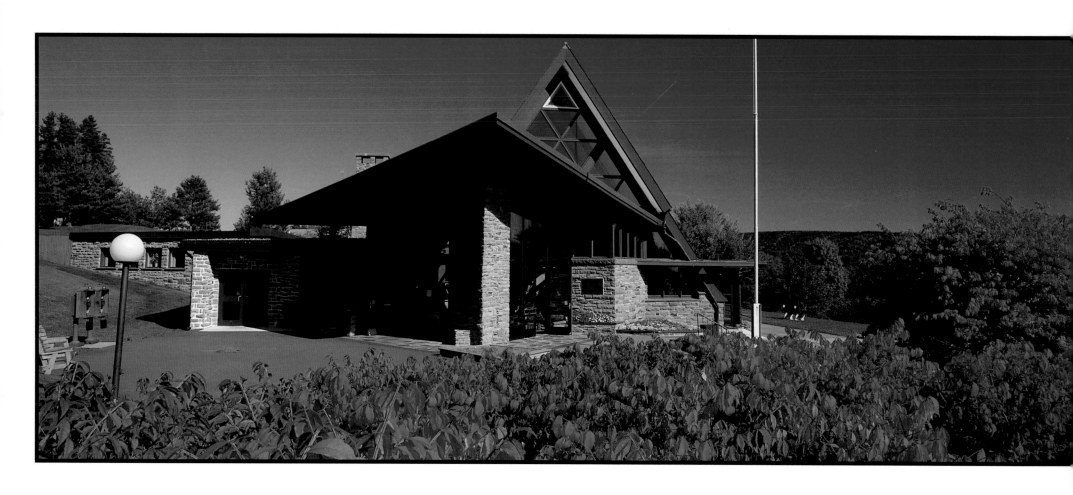

The Alexander Graham Bell Museum in Baddeck, Cape Breton.

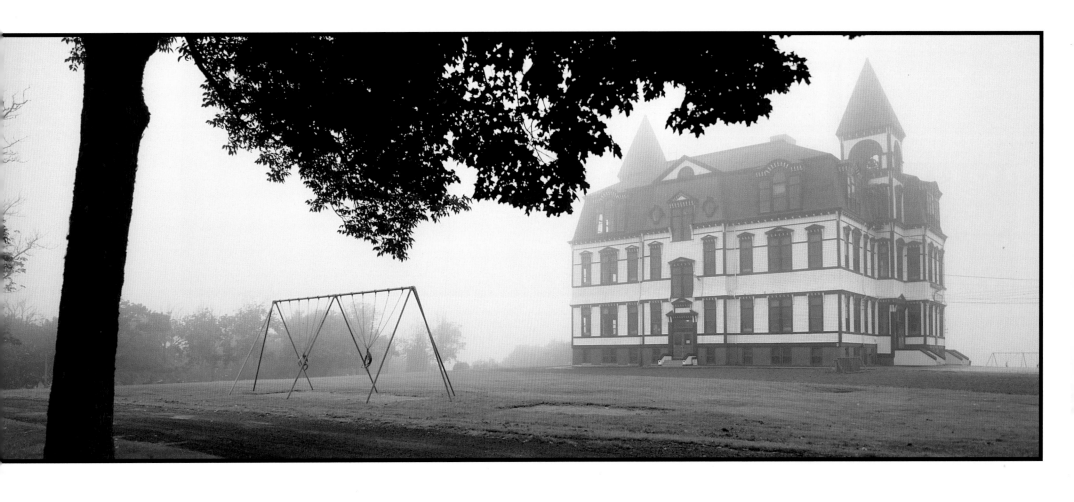

The Lunenburg Academy is a very imposing structure
and was the subject for a Canada Post stamp.

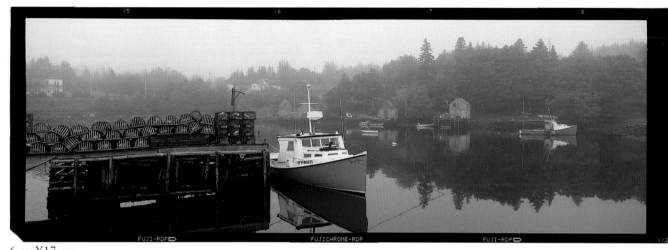

35 mm 6 cmX17 cm

Choosing a format is always a challenge, but the decision is made easy if one allows the scene and composition to inform the choice. A common mistake made by photographers-professional as well as amateur-is to choose a format based purely on the kind of equipment available or on one's intellectual understanding of photography, ignoring the actual scene or subject at hand. The images on this page illustrate how choosing the right format creates a successful photograph. I choose the most suitable format for a scene or subject and stick with it. Or, if I have a 6 cm x 17 cm camera on my tripod, I 'look' only for images that fit the format and focal length lens.

Composing the area of a panorama format requires some thought and special attention. All the formal rules of composition apply, including the 'rule of thirds,' which dictates that the format be divided into sections of thirds, both horizontally and vertically. At each

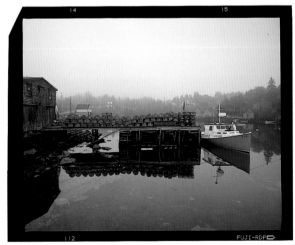

6 cmX7 cm

place where the imaginary lines dissect one another (see diagram), there is a point of impact (1, 2 , 3, and 4). Wherever possible, one should place the subject on or near one of these points of impact. The horizon should be on line A or B for a balanced composition. Also remember that the subject should be the brightest, lightest, or most colourful area of the image. The sweater in this picture draws the eye because it is white, and because I carefully placed it in the lower left point of impact.

	1	2
	3	4

A

B

Rule of Thirds

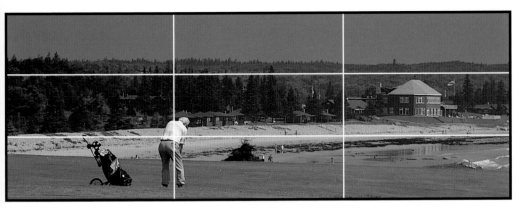
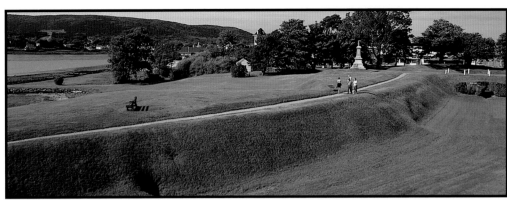

Perspective is a dramatic aspect of any photograph and should be used to the photographer's advantage. When working with the wide field of the panorama image, it is important that the composition make sense. Avoid cramming the subject into either one side or the other, as this creates a visual imbalance. The size or colour value of the left side of the composition should balance the right side. Remember that it's the photographer's responsibility to work around the subject; often balance can be achieved by changing the camera position. As in other formats, panorama images rely on lines of composition. S- and C-curves, diagonal, vertical, and horizontal lines must work if they exist in the scene.

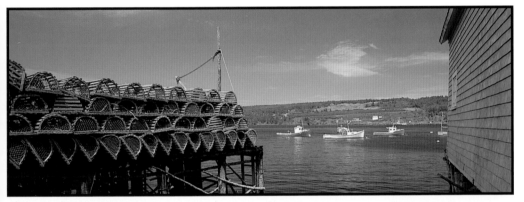
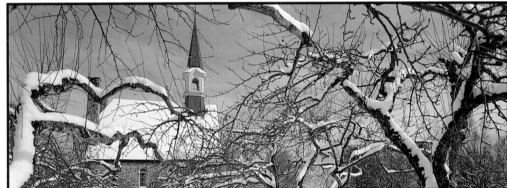

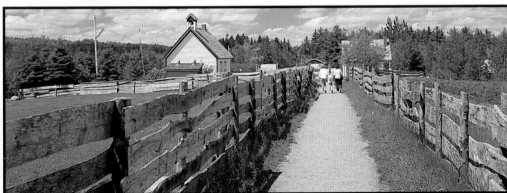

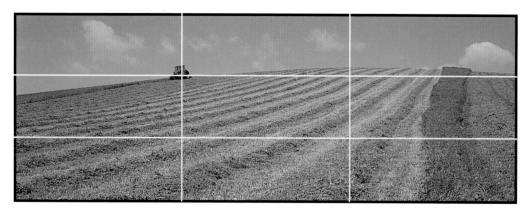 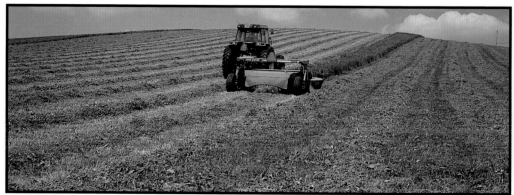

One should master the formal applications of composition before breaking the rules. However, bear in mind that they are only guidelines, and the subject is always the most important consideration. For example, it is admittedly very boring to place the subject in the dead centre of the format. However, sometimes it is simply the best option. In the image above I carefully applied the rule of thirds and placed the horizon in the top third of the image, but I put the tractor smack dab in the centre, and it works. And don't forget that a camera works vertically as well as horizontally. It is common when using a normal 35 mm or 6 cm x 7 cm format to forget to visualize vertical compositions, so to think vertical with a panorama or wide-field-of-view camera is unusual.

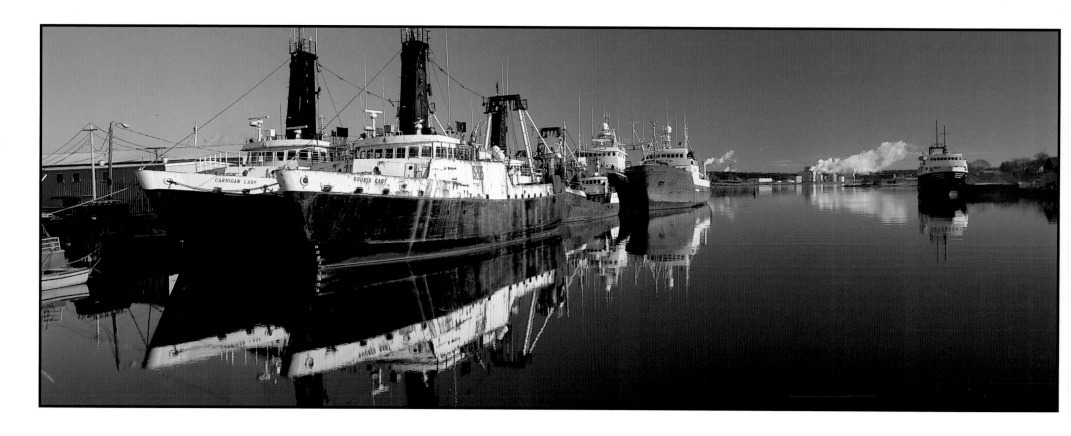

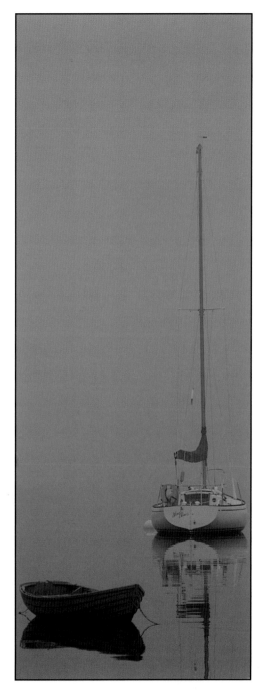

Antique French bronze

Panorama Camera

1845 Dag. curved copper plate 12 cm x 38 cm
 Frederic Martens
 For typographical use.
 A stationary camera with a pivoted lens
 driven by clockwork with a slit that
 travelled. This was later adapted for paper.

1859 Ross & Sutton
 Panoramic water lens of 120° ap. f./12.
 Not corrected for curvature.

1862 Johnson Harrison
 Phantoscopic camera. 7-1/2 x 12 wet
 collodion plates processed in camera.

1889 Cylindrographe
 Col. Moëssoral of France.
 Similar to Martens. 150 mm lens.
 Varnished walnut with silver trim.

1889 "Wonder" J.R. Common of USA.
 A true 360° panoramic view. Wooden
 body. Eastman 3" wide acetate film.

1890 Turntables Style
 Air brake clockwork film carrier moved at
 same speed in opposite direction—film
 speed and diaphragm = exposure.

1896 Al Vista
 Burlington, Wisconsin, USA.
 Roll film.

1899-1928 Kodak Panorama 142°. 3-1/2" x 12"
 #103 Roll film.

1910 Circuit Camera.

1915 Fozmer & Schwing
 USA
 Banquet Camera 7" x 17" and 12" x 20".
 Made for glass plates and later for acetate film.

1959 Widelux 35 mm camera
 24 mm x 59 mm.

1966 Horizontal 35 mm
 Russian
 24 mm x 58 mm f./2.8, 1/30, 1/60, 1/125.
 Lens moves horizontally 120°.

1975 Kalimar
 35 mm film.

1982 Fujica 6 cm x 17 cm.

1994 Kodak 3-1/2" x 10".

1993 Fuji GX617
 6 cm x 17 cm.